GHOSTS
OF SALEM

GHOSTS OF SALEM

HAUNTS OF THE WITCH CITY

SAM BALTRUSIS

Haunted America

Published by Haunted America
A Division of The History Press
Charleston, SC 29403
www.historypress.net

Cover: The Witch House, which was investigated by the Travel Channel's *Ghost Adventures*, is Salem's last structure standing with direct ties to the hysteria of 1692. Home of judge Jonathan Corwin, a magistrate with the Court of Oyer and Terminer, the structure dates back to 1675 and is an icon of America's tortured past.

First published 2014

Manufactured in the United States

ISBN 978.1.62619.397.0

Library of Congress CIP data applied for.

CONTENTS

ACKNOWLEDGEMENTS

Thanks to my spirit squad from Boston Haunts and Cambridge Haunts, including Ashley Shakespeare, Hank Fay, Meaghan Dutton-Blask and Nick Cox for helping me rouse the dead and give a voice to those long departed. My third ghost tour in the "Witch City" helped shape the tone and lore featured in *Ghosts of Salem*. The team at Witch Mansion deserves a supernatural slap on the back for hosting the tour. Major thanks to the handful of paranormal investigators and researchers who helped make *Ghosts of Salem* a reality, including Nick Groff from *Ghost Adventures*, Tim Maguire from the Salem Night Tour, Adam Page from F.I.N.D. Paranormal, Rachel Hoffman, Tina Storer and James DePaul from *Paranormal Xpeditions*, Elizabeth Peterson and Eric Fiahlo from the Witch House, John Denley from Boneyard Productions, Sarah-Frankie Carter from Steps Through 1692, Peter Horne from Cinema Salem, author Margaret Press and the entire research staff at the Salem Public Library. I would like to thank Andrew Warburton, my eagle-eyed Agent Scully and research assistant, who helped uncover some of the skeletal secrets featured in this monstrous project. Thanks to my mother, Deborah Hughes Dutcher, for being there when I need her most and my friend Joe Keville for his continued support. I would also like to thank Tabitha Dulla from The History Press for her support during the process of putting this book together. Special thanks to H.P. Lovecraft for his creative use of *Arkham*-inspired phrases and Stephen King for terrifying me as a kid with the horror classic *The Shining*.

INTRODUCTION

The dead love Salem. Known for its annual Halloween "Haunted Happenings" gathering, it's no surprise that the historic Massachusetts seaport is considered to be one of New England's most haunted destinations. With city officials emphasizing its not-so-dark past, tourists from all over the world seem to focus on the wicked intrigue surrounding the 1692 witch trials.

As far as the paranormal, the city is considered to be hallowed ground.

Originally called Naumkeag, Salem means "peace." However, as its historical legacy dictates, the city was anything but peaceful during the late seventeenth century. In fact, when landowner Giles Corey was pressed to death over a two-day period, he allegedly cursed the sheriff and the city. Over the years, his specter has allegedly been spotted preceding disasters in Salem, including the fire that destroyed most of the downtown area in June 1914. Based on my research, a majority of the hauntings conjured up in Salem over the city's tumultuous three-hundred-year-old history have ties to disaster, specifically the one-hundred-year-old fire that virtually annihilated the once prosperous North Shore seaport.

Cursed? Salem is full of secrets.

It also suffers from a bit of an identity disorder. After several years giving historical-based ghost tours and researching the finale of my *Ghosts of* book trilogy, I came to realize that Salem somehow manages to embrace its dark, witch trials past while simultaneously shutting a door on it.

The city's dualities are at war: Light versus dark. Truth versus fiction. Witches versus zombies. On the one hand, there seems to be a push to

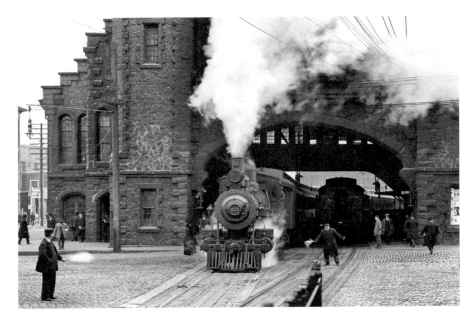

All aboard? Ghostly image from 1910 of the Boston and Maine Railroad depot formerly in Salem's Riley Plaza. Four years later, the Great Fire of 1914 virtually annihilated the North Shore city destroying an estimated 1,376 buildings and possibly leaving what paranormal investigators call an "aura of disaster." *Courtesy of the Detroit Publishing Co.*

pretend that Salem's maritime past was a golden age, but in actual fact, its history is soaked in blood. There's also an intense denial associated with the "Witch City" brand.

Tourists favor it. Locals don't.

When it comes to the "spirit" of Salem, non-witch businesses try desperately to showcase the city's sleepy, New England charm, as if to suggest that yes, Salem is just like any other North Shore village. Historically, it's a hidden gem. However, if you spend more than a few hours digging beneath its architecturally stunning exterior and touristy maritime haunts, the city is anything but "normal."

Salem is a city full of witches and ghosts.

My first experiences in Salem go back a few decades to the early '90s. Of course, I visited every Halloween during college. I loved the specters and spectacles. I walked around, usually with a group of friends, and returned with a few spooky stories to share with the others at the dormitory. It was the place to go every October.

After returning to Boston in 2007, I started visiting Salem throughout the year. Its spirits called me. And I found myself secretly hopping on the train if I needed to recharge my batteries. There's an inexplicable energy in the city. Some say it's hidden beneath the hard, Puritan soil. It's magical at first. It's only if you stay too long that the spark short-circuits.

As a recovering *X-Files* junkie, I've always been more of an Agent Scully than David Duchovny's Mulder. However, after a string of unexplained paranormal encounters over the years, I must admit that I've become more of a believer than a skeptic. However, I've approached *Ghosts of Salem* as a journalist and left no gravestone unturned when it came to digging up the historical dirt on each so-called haunting.

I've spent years investigating alleged accounts of paranormal activity at sites all over New England. I've collected a slew of reports from these supposedly haunted locales, and the mission was to give readers a contemporary take on Salem's bevy of site-specific legends. *Ghosts of Salem* is, in essence, a supernatural-themed travel guide written with a historical lens. Based on my research, the city is a hotbed of paranormal activity.

Incidentally, I have first-hand experience with many of the haunts in the book. My first ghost tour experience in Salem was an impromptu trek on Mollie Stewart's Spellbound tour in 2010. I remember peeking into the windows of the allegedly haunted Joshua Ward House, convinced I saw a spirit looking out of the second-floor window. It turned out to be a bust of George Washington. Soon after writing my first book, *Ghosts of Boston*, I signed on to give historical-based ghost tours of my own in a city that both excited and terrified me. I let Salem's spirits guide me. I had several odd experiences outside of Lyceum Hall, which was believed to be Bridget Bishop's orchard. An apple mysteriously rolled out of nowhere in the alley behind what is now Turner's Seafood. I looked up. No one was there. I accepted it as a peace offering from Bishop, who later became one of my favorite characters on the tour.

As a journalist, there was always a shocking headline to be found parading down Essex Street. For the summer, I worked with a haunted attraction on Essex Street called Witch Mansion. There, I met a few of the characters featured in this book, including Sarah-Frankie Carter, a fellow tour guide who claimed to have a face-to-face encounter with the ghost of Giles Corey at Howard Street Cemetery. We talked a lot about the spirits and curses associated with Salem. "Some say the only real curse in Salem is that once you live here, you never leave," Carter joked.

In 2011, the haunted house on Essex Street was caught in the middle of a well-publicized feud that apparently pitted zombies against witches. According to several reports, the Witch Mansion's competitor, the Nightmare Factory, unleashed a smear campaign claiming that one of its wayward zombies was deliberately tripped up while handing out flyers. "My belief is this is a false report," said my future boss Ken Mendozzi. "No 'bumping' ever occurred…Witches will not be bullied by zombies."

Witch Mansion is next-door to Omen, a popular witch shop housing an altar to the dead. There's a video online from a Witch Mansion surveillance camera showing what looks like an unseen force knocking over a vampire figure in the 186 Essex St. lobby. "We had an employee walk out after seeing that video," said John Denley, the mastermind behind the haunts at Witch Mansion. Yes, one of Salem's haunted houses is also allegedly haunted. "We're in Salem," Denley mused. "Of course the space is haunted."

My most profound encounter in Salem was at the Old Burying Point on Charter Street. I spotted a full-bodied apparition of a lady in white coming from what I learned later was the gravestone of Giles Corey's second wife, Mary. It's my theory that Mary Corey's residual energy is looking for her husband. She's heading oddly toward the very spot where the stubborn but determined old man was crushed to death. Yes, love does exist in the afterlife.

The Samuel Pickman House, which is eerily perched on the corner of Charter and Liberty Streets, became a regular point of interest. One guest on my tour shot a photo from the window that continues to haunt me. The misty, white image looks like a man. Perhaps it's the demonic entity that ghost lore enthusiasts claim possessed the man who savagely murdered his wife and daughter there.

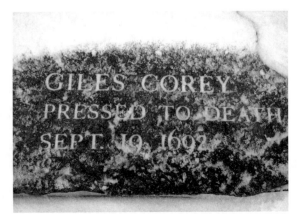

Contrary to popular belief, the Giles Corey plaque at the Salem Witch Trials Memorial next to the Charter Street Cemetery doesn't contain the remains of the twenty victims of the 1692 hysteria. Corey was pressed to death over a two-day period and allegedly cursed the sheriff and the city. The location of his remains is unknown. *Photo by Sam Baltrusis.*

I've also seen what looked like a little girl, who was allegedly abandoned and died, peeking out of the Pickman House window. I remember shivering in the beauty and the madness of the moment. Somehow, I felt her pain.

As the season progressed, the tenor of my ghost tour turned progressively dark. I have been pushed, scratched and tapped by the ghosts of Salem. Some of the spirits were harmless. Others were not.

After Halloween, the city becomes a literal ghost town, and it was during the off-season when my team members did our primary research. My assistant and I spent hours at the Salem Public Library, specifically in the room dedicated to the city's local history. Oddly, the late, great author Robert Ellis Cahill's name kept popping up along the way. Jennifer Strom, the librarian behind Salem Links & Lore, used the Salem ghost lore expert as her Ancestry.com example at the library workshop. Cahill is one of those quirky, local characters I wish I had the honor to meet. After reading his books, I feel like I have.

Apparently, it's common for Salemites to secretly believe in ghosts. Susan Szpak, the librarian specializing in the city's local history, talked about a typical interaction with people researching their house's history. "Most people who do research on their home in Salem think their house is haunted," she said without hesitation. "I tell them, 'Based on the things I hear, I wouldn't be surprised that it is haunted.'" She talked about a few eerie encounters at the former John Bertram mansion, the library's historic space, including librarians feeling like there is a presence in the room. "Mr. Bertram was a great man, so I think he's just checking in to see how things are going in his former home," she says with a laugh.

While writing *Ghosts of Salem*, I've uncovered some historical inaccuracies tied to a few of the city's ghostly legends. For example, the spirit allegedly haunting Ropes Mansion, Abigail, wasn't married to Judge Nathaniel Ropes, as is commonly believed. However, she did die tragically from burns received when carrying coals from one room to another. Yes, sometimes fact is stranger than fiction. Many legends—like William Austin's Peter Rugg literary character, who stubbornly rode his horse into a thunderstorm in 1770 and was cursed to drive his carriage until the end of time—didn't exist. However, people over the years have reportedly spotted the ghostly man with his daughter by his side frantically trying to make the trek back home.

For many, the only real ghosts that exist are the ones that haunt the insides of their heads.

My favorite haunt in Salem is magistrate Jonathan Corwin's former home, also know as the Witch House. My assistant and I met with the director,

Because of its witch trials past, Salem is considered to be one of New England's most haunted destinations. In the background is Old Town Hall, featured in the movie *Hocus Pocus* and home to reported poltergeist activity including furniture moving on its own and ghostly faces peeking out of the windows at night. *Photo by Sam Baltrusis.*

Elizabeth Peterson, and walked around the only standing structure with ties to the witch trials hysteria of 1692. Trekking up the building's creaky stairs, it felt like we were stepping back in time. I swore I heard my name whispered on the first floor of the hallowed structure. The disembodied voice sounded female. My research assistant, a die-hard myth buster, regularly serves up a healthy dose of skepticism while we explore the magical underbelly of Salem. He thinks it was merely the power of suggestion.

I still don't believe him.

Chapter 1

CEMETERY HAUNTS

Haunted burial grounds? It's a no-brainer. As far as encounters with the ghosts of Salem's past, all paths lead to a small, two-block path in downtown Salem called Charter Street. Crafted in 1768, this well-trafficked pathway once connected the town wharf and the present-day Market Street. It also boasts the second-oldest graveyard in the country and arguably Salem's most visited. For the record, the oldest maintained cemetery in the United States is the Myles Standish Burial Ground in Duxbury, Massachusetts, dating back to the pilgrims of 1620. Salem's Old Burying Point, also known as the Charter Street Cemetery, is a familiar location for pop culture representations of the "Witch City," serving as a backdrop for paranormal-themed shows like the Travel Channel's *Ghost Adventures* and Syfy's *Ghost Hunters.*

It's also where Salem's dead people go to chill out, especially after Halloween, when this seasonal tourist destination becomes a literal ghost town. Paranormal investigators, like Adam Berry from Syfy's *Ghost Hunters,* believe the older the cemetery, the more likely it will attract lingering spirits. "Cemeteries are where they go to rest and don't want to be bothered," Berry told *Ghosts of Salem.* "I don't believe they're bound or held captive in that specific spot. However, I do feel they're abundant."

Berry, who spent hours in old cemeteries armed with an electromagnetic voice phenomenon (EVP) recorder before auditioning for *Ghost Hunters Academy* and joining the Atlantic Paranormal Society (TAPS), said burial grounds naturally attract paranormal activity. "Cemeteries have a lot of

activity. The [spirits] want to talk to you, and they may have a story to pass on," he remarked.

As far as Salem's cemeteries, investigator Tina Storer from *Paranormal Xpeditions* said the 1692 witch trials hysteria left a psychic imprint of sorts on the area. "Something as tragic as the witch trials can definitely attract activity, from the mere disrespect that occurred to the bodies after death," she said, adding that the lack of a proper burial for the nineteen innocent victims who were hanged at Gallows Hill and one, Giles Corey, who was pressed to death, could serve as a spirit magnet. However, Salem's creepy burial grounds aren't necessarily the city's most active places. "It's easy to think of cemeteries as being haunted. It's a place associated with death. But I don't think it's any different than any other location personally," Storer continued. "Spirits are everywhere, and cemeteries are just pinpointing a location to their place of rest."

Mike Baker, a scientific-minded paranormal investigator with Para-Boston, echoes Storer's belief. The researcher conducted an exhaustive study for his New England Center for the Advancement of Paranormal Science (NECAPS) on points of geothermal and electromagnetic energy in New England in an attempt to predict active locations. According to Baker, patterns did emerge including a preponderance of paranormal incidents along fault lines, railroad tracks and areas where there are higher reports of UFO sightings. However, the study concluded that graveyards were oddly void of activity. "We left no stone unturned, even cemeteries." Baker said. "We found that there is no correlation to hauntings and cemeteries which goes against what a lot of people believe."

Haunted or not, Salem's cemeteries continue to be a hot spot for ghost lore enthusiasts and amateur investigators. In fact, Sarah-Frankie Carter, a Salem-based tour guide and featured subject on the History Channel 2's documentary highlighting the city's haunted history, said she stays away from the Howard Street Cemetery after having an alleged encounter with the ominous ghost of Giles Corey. However, this infamous cemetery apparently isn't Salem's most haunted. According to Carter, the most active graveyard is in nearby Peabody. "There's one spirit that resides at the St. Mary's Cemetery on Route 114," Carter claimed. "I've seen a full-bodied apparition of a woman there three different times. She's pretty reliable. I've seen her almost every time I've gone in there."

According to multiple reports, visitors at St. Mary's Cemetery in Peabody have spotted "faint white lights" that move around and experienced a foreboding sensation that one should quickly leave. There are also several

EVPs of both male and female voices. Carter claimed she had several close encounters of the paranormal kind with one of St. Mary's resident lady specters.

The first time was around 3:00 a.m. a few years ago, when Carter and her two friends spotted what looked like a plastic bag stuck in a tree. After a second glance, she said it was a female spirit wearing a nightgown. "She crawled out of the tree and started running right at us," Carter emotively recalled. "It was so dark, but we could see her. She was glowing. We were terrified, and we ran out." Carter's second visit was with a psychic friend who also spotted the female phantom. "The spirit was in her twenties, and she died young. I haven't gone back to find her gravestone, but she hangs around a certain spot in the cemetery." The third time that Carter encountered the female specter was with a friend who didn't believe in ghosts. "He looks up and sees her," Carter recalled with a laugh. "He quickly ran out and refused to go back."

Sarah-Frankie Carter, a Salem-based tour guide and featured subject on the History Channel 2's *Haunted History* documentary, claimed to have a face-to-face encounter with the ghost of Giles Corey at Howard Street Cemetery. She says her favorite haunted hot spot in the area is St. Mary's Cemetery in Peabody. *Illustration by John Clinkscale.*

Why does so much ghost lore surround Salem's old-school burial grounds? "People are fascinated with cemeteries," explained the late, great historian Jim McCabe in a 2007 interview with the *Boston Herald*. "It's like going to a historical house."

BROAD STREET CEMETERY

As far as haunted cemeteries in Salem, the second-oldest burial ground in the city is often overlooked. Because of its relative seclusion on Lawes Hill, a small mound bordered by Summer, Broad and Gedney Streets, this picturesque cemetery located a mere stone's throw from the allegedly haunted Salem Inn and the Witch House is rarely visited by the living. But it's apparently a hot spot for the dead.

Why? Broad Street Cemetery was established in 1655 and is the final resting place for Court of Oyer and Terminer judge Jonathan Corwin, as

Established in 1655, the Broad Street Cemetery is the final resting place for Court of Oyer and Terminer judge Jonathan Corwin, as well as his notoriously sadistic nephew, high sheriff George Corwin. *Courtesy of the Detroit Publishing Co.*

well as one of Salem's more infamous players from the 1692 witch trials era, Corwin's sadistic nephew, high sheriff George Corwin. After mysteriously dying from a heart attack at age thirty, the younger Corwin was arguably the city's most despised man. And rightfully so. The then twenty-something sheriff reportedly got a kick out of torturing the men and women accused of witchcraft. Although it was the uncle, Magistrate Jonathan Corwin, who tried and accused the innocents, it was the sick and twisted nephew who enforced the unjust verdicts.

"Sheriff Corwin was so disliked by the people of Salem, that when he died of a heart attack in 1696, his family didn't dare bury him in the cemetery for fear he'd be dug up and his body torn limb from limb," wrote Robert Ellis Cahill, himself a former Essex County sheriff turned author, in *Haunted Happenings*. Corwin's cruelty is legendary. For example, he sent an officer to accused witch Mary Parker's home in Andover on September 23, 1692, literally the day after her execution, demanding that her son fork over the dead woman's farm and goods. Parker's son, who was still mourning the

loss of his mother, had to cough up a large sum of money to stop Corwin's demands for corn, hay and cattle.

Of course, Corwin is also known as the man who tried to squeeze a confession out of Giles Corey, the elderly landowner who was pressed to death after a torturous two-day ordeal. "Do you confess?" demanded Corwin, as his men piled more rocks on the stubborn Corey. Corwin reportedly would stand on top of the rocks as the old man demanded "more weight."

"In the crushing, Giles Corey's tongue was pressed out of his mouth and the sheriff, with his cane, forced it in again," wrote Robert Calef in his account of the torture. According to legend, Corey cursed the sheriff and Salem right before he passed. "Damn you, Sheriff," Corey allegedly cried out. "I curse you and Salem."

When Corwin died in 1696, he was a wanted man. Phillip English, a wealthy merchant who fled Salem to Boston and ultimately New York with his wife, Mary, after wrongfully being accused, supposedly threatened to place a lien on Corwin's body until his property was returned. For the record, the sheriff's cronies had ransacked English's estate and English demanded posthumous justice. Corwin was buried beneath his home, at the current location of the Joshua Ward House at 148 Washington Street, and was later moved when tempers cooled to the Broad Street Cemetery with his equally disliked uncle, Judge Jonathan Corwin.

As far as hauntings, Corwin's final resting place is said to be a lesser-known hotbed of paranormal activity. Floating orbs of light, an indicator of high levels of residual psychic energy, have been spotted in the cemetery. There have been several reports of an apparition of an older gentleman wearing period garb wandering the old-school gravestones. One spirited encounter from 1975 indicates that the Broad Street Cemetery ghost is a whistler. "All of sudden, a glimmer of white caught my eyes," recalled one visitor interviewed by the *Boston Globe* in October 1975. "There, on a grave to the right, was a man's shoulder, the shadow of his head was turning, and out from his mouth came a jagged, high-pitched whistling sound." The freaked-out witness continued, "Something that night didn't want us around Salem. Driving away, we believed that it was Corwin, warning us to leave, not to deal in forces and intrigues we were just novices at."

Is it Sheriff Corwin's spirit? Perhaps. However, the descriptions of the garb of the "whistling man" spirit seem to date back to the eighteenth century. Also, Corwin's spirit is rumored to linger at his former homestead, the land currently occupied by the Joshua Ward House. Meanwhile, it's

said that the residual energy of Corwin's uncle supposedly left its imprint at the nearby Witch House.

One theory suggests that the whistling specter isn't a Corwin but a man called Jonathan Neal.

Broad Street Cemetery is directly across from Salem's picturesque Chestnut Street neighborhood, which continues to be a hub of photo-seeking tourists. The Jonathan Neal House, originally thought to have been built by its namesake in 1767, is now believed to date back to 1652 thanks to the discovery of a deed proving the conversion of a barn on the property forty years before the Salem witch trials hysteria. Oddly, Neal suffered a freakish death in 1790. The carpenter from Marblehead and grandson of early settler John Neal ran a local waterfront warehouse and, after drinking a few too many in a "house of intemperance," fell head first into the mud and died tragically. Based on the research of famed paranormal investigators like the late, great Dr. Hans Holzer, it's common for spirits who have died accidentally while intoxicated to stick around.

Some believe Neal may be what is known as a "stay behind" who lingers in the area surrounding the Broad Street Cemetery near his home. Holzer, in an interview in 2005, explained the phenomenon. "'Stay behinds' are relatively common," he said. "Somebody dies, and then they're really surprised that all of a sudden they're not dead. They're alive like they were. They don't understand it because they weren't prepared for it. So they go back to what they knew most—their chair, their room, and they just sit there. Next, they want to let people know that they're still 'alive.' So they'll do little things like moving things, appear to relatives, pushing objects, poltergeist phenomena, and so on."

The odd thing about Neal is that he was known to whistle and was possibly doing so when he fell face first in the mud that freakishly killed him. Spine-chilling whistles from the afterlife? Yep, it's an attribute of one of the many spirits of Salem hanging out in its historic cemeteries.

File under: whistler's ghost

HOWARD STREET CEMETERY

While it's not Salem's oldest burial ground, Howard Street Cemetery is reportedly its most haunted. Opened next to the old Salem Jail, the spooky graveyard on a hill is the final resting spot for seafarer Benjamin Ropes,

who was buried there on August 5, 1801. Cause of death? Ropes was fatally crushed while launching the historic ship *Belisarius*'s top mast. Oddly, a large percentage of those buried in the Howard Street Cemetery had a fate similar to Giles Corey, the only witch trial victim who suffered the "peine forte et dure" form of execution. Yep, a large percentage of those buried there were accidentally or purposefully crushed.

"We did some research with the city, and we found that a high number of the people buried in the Howard Street Cemetery, around 15 percent, were crushed to death," explains historian and Salem Night Tour co-owner Tim Maguire. "It's so interesting because that was the site where Giles Corey was crushed to death during the witch trials."

The Salem Night Tour owner rattled off a series of bizarre "accidents" of those buried at the Howard Street Cemetery. "For example, the floor of the jail collapsed and killed ten prisoners," he said. "A high number of people buried there were crushed to death because of various accidents."

Considered to be Salem's most haunted burial grounds, Howard Street Cemetery is the site where landowner Giles Corey was crushed to death over a two-day period. It's also where locals allegedly spot Corey's full-bodied apparition before tragedy strikes Salem. *Photo by Sam Baltrusis.*

Maguire was a featured player on the History Channel 2's documentary focusing on a handful of Salem's alleged haunts. The evidence he unveiled on the show, specifically a photo taken at the Howard Street Cemetery, was shocking. The picture looked like a crowd of Puritan-era revelers, gathered in a lynch mob sort of way, around what is believed to be the exact spot where Corey was stripped naked, placed under a wooden board and crushed to death over a two-day period in 1692.

"Someone on my tour took a photo of the cemetery," Maguire said on the History Channel. "By the end of the tour that person came forward to share the photo they took. Definitely not what we were looking at. There seems to be figures of people standing over someone. Most people who feel like they found the spirit of Giles Corey or have seen his apparition, they think it's a reminder of what we have done to him there."

Maguire told *Ghosts of Salem* that he rarely gives daytime tours. However, a Christian-based group requested an earlier time slot one day, and they snapped the infamous picture. "In the photo, you see what looks like flames in the background, and you can make out a couple of faces in the photo," he said, convinced he captured something paranormal. "When we were standing there, it was a nice, clear sunny day."

Over the years, Maguire said he's heard of multiple Corey sightings. "People often see an old man go around a tree in there. It seems to be the spirit of Giles Corey," he said, adding that the burial ground's proximity to the old Salem Jail adds to its negative energy. "What's interesting about the Howard Street Cemetery is that it was built to accommodate inmate atrocities. It was the only coed jail in the country. Women were on one side, men on the other and children in the middle. There was a four-year-old boy who served a two-month sentence for breaking something."

It's common for visitors to report heart palpitations or a sensation of a heavy weight being placed on their upper body, just like the stubborn landowner who had rocks placed on his chest. It's also the norm for Salemites to mention Corey's curse.

"All of the Essex County sheriffs who overlooked that property eventually died of a heart-related ailment," said Maguire. "Robert Cahill [author of *Haunted Happenings* and sheriff who lived to seventy] was a firm believer in the curse. He had a bizarre blood ailment they couldn't diagnose. It's believed that Corey cursed the city and the sheriff in blood…and we have proof."

And if someone sees his apparition? Salem allegedly burns.

"My friend and I were exploring the Howard Street Cemetery," recalled Sarah-Frankie Carter on the History Channel. "There was a very creepy

feeling as we got closer and closer to the spot where Giles Corey was actually pressed to death. My friend wiggled through a fence to see if she could get a closer look at the jail, and I heard her scream. She said she saw a man standing at the top of the stairs. We both had a really bad feeling."

Carter echoed the legend that if the "skeleton of Corey's ghost in tattered old clothes" appears, something horrible will happen to the city. "They say if you see Giles Corey, Salem burns. And if he speaks to you, you die," she said, adding that Salem did, in fact, go up in flames after her Corey sighting. "I was listening to my local college radio station, and they said there were fires in Salem. Needless to say, I don't go to that part of Salem anymore, especially at night. I don't think he gives you that many chances."

Locals believe in Corey's curse. In fact, author Nathaniel Hawthorne claimed that the apparition "of the wizard appears as a precursor to some great calamity impending over the community."

According to several accounts, Corey's spirit was spotted near the Howard Street Cemetery days before the Great Fire of 1914 that completely annihilated two-thirds of the city. Ironically, the inferno began in Gallows Hill, where nineteen innocents were hanged, and the conflagration destroyed one-third of Salem. "Before the Great Fire of 1914, there were almost three hundred accounts of local Salemites who had gone to the sheriff's office and reported this old man in raggedy clothes that they tried to help and then who vanished," confirmed Maguire, adding that he doesn't have solid proof of the lore. "They put enough stock into these accounts that the sheriff put deputies around the Howard Street Cemetery. They actually watched that cemetery for six or seven hours and when they had left, the Great Fire happened about a half-hour after."

Apparently, Corey's spirit continues to hold the city of Salem accountable.

File under: grave matters

Old Burying Point

History and mystery oozes from the oldest burial ground in Salem. Also known as the Charter Street Cemetery, the Old Burying Point dates back to 1632, contains the remains of 347 bodies and is the second-oldest cemetery in the country. In addition to its historical relevance, it was a regular haunt for Salem's native son, Nathaniel Hawthorne, author of the classics *The Scarlet Letter* and *The House of the Seven Gables*.

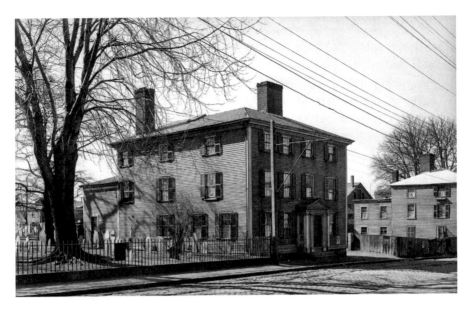

Author Nathaniel Hawthorne met his wife, Sophia Peabody Hawthorne, at a lavish dinner party at the Grimshawe House, 53 Charter Street, next to the Old Burying Point. According to legend, Sophia suffered from migraines, and the couple would take midnight strolls in the cemetery. No surprise, but names from the gravestones in the Charter Street Cemetery often appear in Hawthorne's writings. *Courtesy of the Detroit Publishing Co.*

Buried in the Charter Street Cemetery is Hawthorne's ancestor John Hathorne, a witch trial judge whose memory haunted him. In fact, Hawthorne added the "w" to his name to distance himself from his infamous great-great grandfather. Yes, *The Scarlet Letter* writer abhorred his familial connection to the 1692 witch trials hysteria. At least eight members of his family were interred there, including his grandparents and two of their daughters. Witch trial judge Bartholomew Gedney, poet Anne Bradstreet, architect-carver Samuel McIntire and *Mayflower* passenger Richard More are all buried there. No surprise, but names from the gravestones in the Charter Street Cemetery often appear in Hawthorne's writings. For example, the small gravestone of Hehzhibah Packer, who died in 1684, possibly inspired Hawthorne to use the unusual name of Hepzibah in his novel *The House of the Seven Gables*. The same novel also features a character called "John Swinnerton," who shares his name with a real-life Salem doctor buried in the cemetery in the late seventeenth century. The cemetery was also featured in Hawthorne's *Dr. Grimshawe's Secret.*

The Salem-bred author met his wife, Sophia Peabody Hawthorne, at a lavish dinner party at the Peabody family home located at 53 Charter Street, literally next-door to the Old Burying Point. Today it's known as the Grimshawe House. According to lore, Sophia suffered from migraines, and the couple would take midnight strolls in the cemetery. It's believed that the headaches were the result of drugs her father, a Salem dentist, prescribed to her during early childhood to ease her difficulty with teething. The Peabody family lived there between 1835 and 1840 before they moved to Boston.

Today, the Old Burying Point lies adjacent to the Witch Trials Memorial, a small park dedicated in 1992 to honor the memory of the men and women who were executed for witchcraft in 1692. The Grimshawe House, now in disrepair, stands as an eerie reminder of Salem's nineteenth-century grandeur.

As far as paranormal activity, the Charter Street Cemetery is the usual finale for Salem-based ghost tours. Sensitives claim to have an overwhelming feeling of sadness and depression walking through the graveyard and the adjoining Witch Trials Memorial. Some believe the area is tied to a disaster. According to lore, a former inn on Charter Street caught on fire, and a woman and her son escaped while her husband remained inside to put out the blaze. They ran back in for him, but he was dead.

"In the back corner near Murphy's Restaurant and Bar, a woman in a Victorian-era powder blue dress can be seen holding a picnic basket and a young boy in short pants, black shirt and hat is always seen with her," reported the website Witch City Ghosts. "Often cameras malfunction but when they do operate properly, the pictures capture bight white streaks of light, paranormal orbs and odd mists."

It's believed that the Victorian-era lady in blue and her son died in the nineteenth-century fire. Apparently, the back corner of the cemetery closest to Murphy's Restaurant is a hot spot for the paranormal. "According to legend, a casket once broke through the wall and fell into the building," added Leslie Rule, writing about the restaurant in *When the Ghosts Scream*. "Employees insist it really happened and point to part of the wall that obviously has been patched. No one knows the identity of the ghosts who wander through the restaurant, but some wonder if they may indeed have escaped from the cemetery next door."

Tim Maguire, co-owner of the Salem Night Tour, said he's heard stories and has seen convincing photos supporting claims that a casket did indeed break through the wall at Roosevelt's Restaurant. "It looked like it was a casket of a small child, possibly a girl," he claimed. "The corner of the

cemetery near Murphy's Restaurant is where the Irish Catholics were buried. So, I'm not surprised that it's extremely active."

In addition to orbs and full-bodied apparitions spotted in the cemetery, reports suggest that visitors regularly see a "Lady in White." Oddly, she's rarely captured in photos and film. "The cemetery has been the site of the occasional ghostly appearance of a lady in white," wrote Christopher Forest in *North Shore Spirits*. "The ghost itself does not typically appear in person. Rather, it often manifests itself in the form of orbs. It has even appeared as a slight figure in pictures taken at the site."

The Lady in White has been spotted in buildings and even in the parking lot near the Charter Street Cemetery.

According to a report from North Andover's *Eagle-Tribune* in October 2001, the former owner of Roosevelt's Restaurant (the current spot of Murphy's Restaurant and Bar) said he spotted a female apparition when he was working alone in the restaurant at 3:00 a.m. "I was on the second floor," recalled Henry McGowan. "I actually looked up and saw somebody

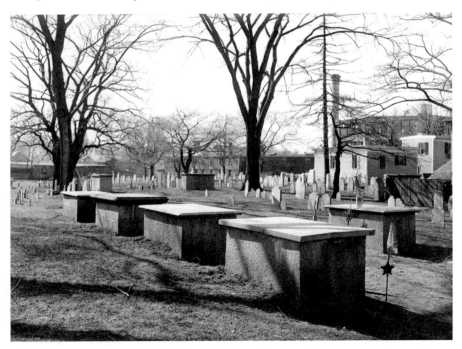

The Old Burying Point, also known as the Charter Street Cemetery, dates back to 1632 and boasts a full-bodied apparition of a lady in white. Some believe it's Giles Corey's second wife, Mary, levitating in the direction where her beloved husband was pressed to death. *Courtesy of the Detroit Publishing Co.*

looking down at me. It was a woman." He did a double take, and the phantom vanished.

So, who is the Lady in White? Within the Witch Trials Memorial, one commemorative stone honors witch trial victims Giles Corey and his wife, Martha. However, his second wife, Mary Corey, was also buried in the Old Burying Point. A small, white gravestone with the words "Mary Corry [*sic*], wife of Giles" marks her skeletal remains. Historians surmise that Giles was very much in love with his second wife. In fact, she's considered to be the love of his life. Oddly, the lady in white has been seen coming from the general vicinity of her grave marker, and many believe it's her spirit that continues to levitate across the cemetery headed toward the Howard Street Cemetery in the area where her beloved husband was pressed to death.

Based on encounters, Corey's spirit simmers with a postmortem resentment after being crushed to death under a pile of stones more than three hundred years ago. However, if anything has the power to undo the curse unleashed by Corey, it's surely his enduring love for his second wife. Perhaps Mary's spirit is searching for her tortured husband…and if the two spirits finally meet, the curse will be undone. Yes, love exists even in the afterlife.

File under: curse reversed

St. Peter's Church

A bald male apparition with a grudge? According to several accounts, the makeshift cemetery in front of St. Peter's Church boasts a motley crew of residual hauntings. This historic house of worship was established in 1733 after the land on which it was built was donated by Phillip English, a wealthy man originally from the British Channel Islands. He owned a fleet of twenty-one ships, several buildings throughout town and a palatial mansion on Essex Street. English was arguably the richest man in Salem as of 1686, which is probably why he and his wife were accused of practicing the dark arts during the hysteria six years later.

On Saturday, April 18, Sheriff George Corwin and his cronies served a warrant for the arrest of Mary English, Phillip's wife. The following day, Corwin brought her to the Cat and Wheel, a tavern near the old meetinghouse, and she was locked in a room on the second floor. Examinations of supposed witches were held at Salem's taverns, so it's no surprise that the local watering hole was used as a more humane holding cell compared to the hell-on-Earth

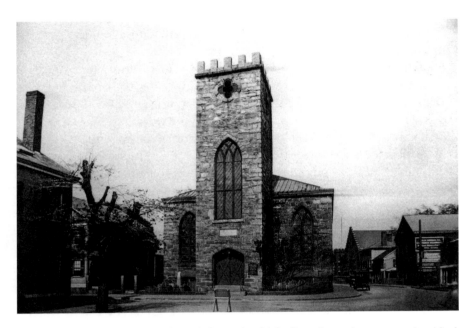

Established in 1733, St. Peter's Church, located at 24 St. Peter Street, boasts several residual hauntings, including a bald male apparition and a female phantom emerging from a wooden door salvaged from the original church. *Courtesy of the Boston Public Library.*

dungeon located near Federal Street. Phillip was heartbroken and would visit his wife three times a day. While Mary was being held prisoner, one of the afflicted girls, Susannah Sheldon, accused Mary's husband of being a witch. She said English "stepped over his pew and pinched her" during a church service on Sunday, April 24, "in a very sad manner." Sheldon also claimed that English brought her the devil's book and forced her to sign it or he would cut her throat. Weeks before, Sheldon had claimed to have seen Mary's apparition alongside a dark man with a tall hat.

Because of his social status, Phillip English was sent to Boston. While he was held captive in the neighboring city's more relaxed prison, he arranged for his wife to join him. During their stay in the state's cultural hub, which involved supervised overnight lockdowns, they attended a service at the First Church in Boston. During the sermon, the ministers read Mathew 10:23: "When they persecute you in one town, flee to another." English listened. The unfortunate couple maneuvered a prison break and fled to New York in a carriage donated by one of their friends.

During the witch trials hysteria, food was scarce in Salem because of a drought, and English, who learned about the horrors happening back home,

sent a ship full of corn to feed the suffering. The couple returned to Salem in May 1693 after the governor of Massachusetts, Sir William Phips, issued a general pardon of the remaining accused witches. The Englishes were free, even though they were traumatized by the capricious ordeal.

According to lore, English held a lifelong resentment against Judge Hathorne. He was also enraged that Sheriff George Corwin had ransacked his palatial Salem estate on Essex Street, confiscating up to £1,500. After returning to the "Witch City," his wife died during childbirth in 1694, and English passed forty-two years later, still suffering from lingering resentment and seeking revenge on both the magistrate who accused him of witchcraft and the sheriff who destroyed his property. The two makeshift burial grounds in front of St. Peter's Church today boast twenty-three grave markers. English, whose spirit is rumored to linger in the cemetery, is buried on the church grounds. In fact, his grave is one of only three known final resting spots of accused witches in America.

Some visitors on Tim Maguire's Salem Night Tour have captured what appears to be a full-bodied apparition of a man hiding behind the gravestones. Is it English?

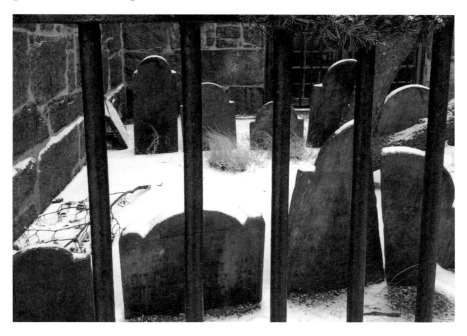

There are two small burial grounds outside of St. Peter's Church. The collection of gravestones in front of St. Peter's was moved to various spots, including inside the chapel walls, so the skeletal remains don't necessarily match up with the gravestones. *Photo by Sam Baltrusis.*

"We've had odd photos coming from the back door of the church. It's funny because it tends to be a bald, modern-looking guy," explained Maguire. "It's a common occurrence for a bald guy to show up in photos at St. Peter's Church. Obviously, he isn't a part of the tour." According to other reports, the bald man is seen crouching behind a gravestone as if he's expecting a severe beating.

Maguire's Remember Salem gift shop located at 127 Essex Street is oddly in the exact spot of one part of English's former mansion, which lies around the corner from St. Peter's Church. The basement of the gift shop, which is the starting point of the Salem Night Tour, is reportedly home to a negative poltergeist known to throw items and yell at people who dare to venture below. "There are places in Salem I don't like. Like the basement here, I don't go down there alone," Maguire explained at Remember Salem. "I've run into more activity in Salem than anywhere else. Most of my life, I've encountered residual, non-intelligent, non-responsive type of activity. Salem seems to have a lot more intelligent hauntings and they tend to screw with people here."

Some believe the residual energy is possibly tied to English's former homestead on Essex Street. "About four years ago, we heard a man's voice come over our soundtrack in the store, and he clearly said: 'I see you. I watch you,'" Maguire said. "We've had employees and customers see a little girl on the back steps. We've recorded several EVPs, and the little girl is often picked up. She has told us through EVPs that she hides from others."

As far as St. Peter's Church, it was originally a wooden building and was rebuilt as a stone structure in 1833. In addition to the ghost lore associated with the "bald man," the chapel in the rear of the church was built in 1833 literally on top of part of the cemetery. In fact, the collection of gravestones in front of St. Peter's was moved to various spots, including inside the chapel walls, so the skeletal remains don't necessarily match up with the grave markers. Today, two small cemeteries are situated on either side of the church's red, front door. Ghostly figures are reported hovering around the area where their old graves are situated. There's also a wooden door salvaged from the original church, and a female spirit, wearing shackles, is reported to appear emerging from the eighteenth-century structure. Some believe the female specter is Mary English. There are other sightings of male spirits who lean against the cemetery's back wall and watch the living as they escape the crowds marching up and down Essex Street.

If English does indeed haunt the land surrounding St. Peter's Church, it may have been triggered by an ironic twist involving the man he reviled most,

Judge John Hathorne. Two of English's granddaughters married Hathorne's grandsons. While English may not haunt the church, it's believed that he continues to turn over in his grave centuries after his death.

File under: English lesson

Chapter 2

CRIME HAUNTS

W hen it comes to the explicable in Salem, it's not always an open-and-shut case. "People want to find patterns if something doesn't make sense," explained Margaret Press, a Salem-based crime writer and author of *Counterpoint: A Murder in Massachusetts Bay*. "Salem makes it easy for us to find these patterns because of historic accident. It's not in the ground. It's not in the air. It's in ourselves."

Press, who penned the essay "Salem as Crime Scene" in the book *Salem: Place, Myth and Memory*, talked about how thousands of visitors make a pilgrimage to the city every October looking for "the occult, the weird and the unexplained," and they find it. "Despite its name, from the Hebrew word for peace, the tourists who flock to the city are convinced the city is about witches and death," Press wrote. "They buy mugs and T-shirts and wander the museums. But beneath it all they're looking and listening. Salem battled him once. But is Satan really gone for good?"

In Press's world, Salem's emphasis on its "specters and spectacles" has a downside. "We're not training our young people in critical thinking," she told *Ghosts of Salem*, slamming the city's proliferation of so-called psychics and palm readers. "If people accept pseudo-science or crap science, there's a real practical downside. It's no better than 1692."

However, Press did coin the phrase known as the "Salem factor," which she used to explain the city's abundance of bizarre synchronicities—like how the Great Fire of 1914 oddly started in the exact spot where nineteen innocents were hanged for witchcraft. However, the author believes there

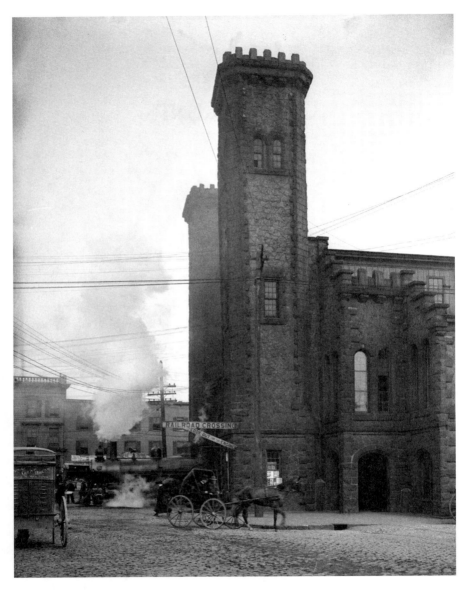

"People want to find patterns if something doesn't make sense. Salem makes it easy for us to find these patterns because of historic accident. It's not in the ground. It's not in the air. It's in ourselves," said crime writer Margaret Press. Historic photo from 1910 of the Boston and Maine Railroad depot formerly in Salem's Riley Plaza. *Courtesy of the Detroit Publishing Co.*

are rational explanations for the inexplicable. "We find coincidences and connections in the human experience here because we expect them," she wrote. "We look for the extraordinary in events here and we see it."

Press cites the controversy surrounding Fatima's, a two-decade-old psychic studio in Salem, which made national headlines in 2013 after an employee charged a New York man $16,800 to protect him from a curse, as proof of society's gullibility to Salem's "boo! business." For the record, the man was reimbursed based on a city ordinance stating that psychics can only forecast the future and read the past. Curses are apparently off-limits.

Christian Day, owner of two witch-themed shops in Salem, didn't like how a local police detective categorized Fatima's Romani style of fortunetelling as fraudulent. "If they're a fraud, then we're all frauds, and all religion is a fraud," Day told the *Boston Globe* on October 31, 2013. "They're not regulating the priest who absolves you of your sins and tells you to put some money in the collection basket, or the old lady who sends all of her money to Pat Robertson. They pick on us for one reason: They're afraid of us. They've always been afraid of us."

Oddly, Press herself made similar headlines when she included a section in her book *Counterpoint* suggesting that legendary Salem witch Laurie Cabot divined the whereabouts of murder victim Martha Brailsford in 1991. The legend supposedly gave a tip to police about the local woman's accused perpetrator, Tom Maimoni, and then continued to put a binding spell on him. "Laurie closed her eyes and pictured Tom Maimoni in a white cocoon, bound up in a thread of light," Press wrote. When asked about the section in her book about Cabot, Press shrugged it off. "The press picked up on it and made it sound like Laurie Cabot cracked the case," Press responded. "She didn't."

Compared to Press's Agent Scully–esque skepticism, Tim Maguire from the Salem Night Tour is a true believer. Maguire has a more *X-Files*-style explanation for the so-called Salem factor. "There's an energy here that's different. I feel it a lot stronger in Salem than say Boston," he said. "A lot of places like Gettysburg and the Bermuda Triangle, there tends to be electrical issues. Salem has an electrical fault under the city. People who visit here notice that their cellphones drain fast. There are electrical oddities that were noticed by the Native Americans in 1618. They considered it a spiritual place and thought it was odd that Europeans wanted to stay in Salem."

Maguire said these electrical anomalies explain why Salem is supposedly a hotbed for the paranormal. "The Native Americans talked about seeing things here…or feeling a presence here," he continued. "When I'm doing a

paranormal investigation in Salem, I have to let people know that when they put their meter on the ground they're going to pick up stuff because Salem has an electrical issue."

The Salem factor? Blame it on the electrical issues, or what some call "ley lines" buried beneath the city's blood-soaked Puritanical soil.

GARDNER-PINGREE HOUSE

It's arguably Salem's crime of the century. The murder of Captain Joseph White, an eighty-two-year-old shipmaster and trader, riveted the nation in 1830 and inspired literary giants like Edgar Allen Poe and Nathaniel Hawthorne.

The crime scene, a three-story brick mansion built in 1804 and located at 128 Essex Street, is believed to boast a residual haunting, a psychic imprint of sorts replaying the savage murder of White, who was whacked over the head with a twenty-two-inch piece of refurbished hickory, also known as an "Indian club," and stabbed thirteen times near his heart. According to several reports, a full-bodied apparition peeks out of the second-floor window. A female spirit rumored to be White's niece, Mary Beckford, who served as his housekeeper in addition to being his next of kin, is also said to haunt the Essex Street house. Beckford's daughter, also a Mary, was formerly part of the household in the 1820s but moved to Wenham with her husband, Joseph Jenkins Knapp Jr.

Every major city has one: a murder house. In Salem, it's known as the Gardner-Pingree estate.

"There were two guys from Oregon who came here to debunk things and they captured on video what seems to be a man looking out of the window," recalled Tim Maguire from the Salem Night Tour. "Of all of the places we visit, we get the most photographic evidence from the Gardner-Pingree House. I've been inside the house a few times and I feel more of a presence of a woman. There's definitely a female presence there."

Psychic imprint from the past? Paranormal investigators like Adam Berry from *Ghost Hunters* believe that residual energy associated with heinous crimes, specifically murders, has potential to leave a supernatural imprint. "Anytime there's a traumatic event, it could be left behind," Berry said. "If you walk into a room and two people have been arguing, fiercely, you can feel that weirdness that they've created or energy they emit spewing at each other. I do think there's a form of energy that can be left behind from a

The Gardner-Pingree House, 128 Essex Street, allegedly contains an anniversary haunting of the murder of Captain Joseph White, an eighty-two-year-old shipmaster and trader. *Photo by Sam Baltrusis.*

traumatic event or any kind of murder or suicide in a room. The theory is that maybe that energy goes into the walls and lingers there."

As far as the murder, it's a complicated puzzle that has been twisted over the years. Captain White's grandnephew, Joe Knapp, learned that the retired merchant had just completed his will, leaving $15,000 to Mrs. Beckford. Knapp believed if White died without a will, his mother-in-law would inherit half his fortune of $200,000. So, Knapp and his brother John hired a black sheep from the respected Crowninshield family, Richard, to slay the captain in his sleep for a mere $1,000. Knapp had access to White's Essex Street home, and in April 1830, he stole the will and left the back parlor window unlocked. Beckford and her daughter Mary were staying in Wenham.

Crowninshield slipped into the mansion at night "entering the house, stealthily threaded the staircase, softly opened the chamber door of the sleeping old man." He killed him with a single blow to the left temple, according to an account in the April 1830 edition of the *Salem Observer*. Crowninshield hid the murder weapons under the steps at the former Howard Street meetinghouse. The bludgeon, a hickory-stick club, was "fashioned to inflict a deadly blow with the least danger of breaking the skin. The handle was contrived as to yield a firm grasp to the hand."

As far as the crime scene, White was in his bedchamber lying diagonally across the bed on his right side. Blood oozed from the thirteen stab wounds, and oddly, no valuables in the house were missing. Because there was no theft, police detectives were baffled at first. The Knapp brothers falsely claimed they had been robbed by three men en route to Wenham, which added some initial confusion to the murder mystery.

A gang of assassins in Salem? Yes, there were three, but it was the Knapp brothers and murder-for-hire crony Richard Crowninshield, who later hanged himself with a handkerchief tied to the bars of his prison cell before he was convicted. The Knapp brothers were then put on trial after the prison suicide.

Daniel Webster, giving arguably one of his most famous legal orations, served as the Knapps' prosecutor and called the affair "a most extraordinary case" and a "cool, calculating, moneymaking murder." The Knapp brothers, admitting they had planned the crime and fabricated the robbery story, were convicted. Meanwhile, it's believed that Edgar Allen Poe was inspired by Webster's speech and penned "The Tell-Tale Heart," a classic short story involving the guilt and retribution associated with the grisly murder of an older man. Hawthorne was also entranced by the trial and explored similar themes in *The Scarlet Letter* and *The House of the Seven Gables*.

Thousands gathered in downtown Salem to watch their public executions. John Francis Knapp was hanged on September 28, 1830, in front of a blood-soaked haunt from Salem's past: the former Witch Gaol, or witch dungeon, currently located at 10 Federal Street. His brother Joe, considered to be the mastermind behind the crime, met a similar fate three months later in November. The infamous murder weapon, the custom-made "Indian club" that measures more than twenty-two inches, is owned by the Peabody Essex Museum. Unfortunately, the macabre artifact isn't on display today, but visitors can tour the refurbished mansion.

According to several reports, the historic murder repeats itself spectrally on the anniversary of Captain White's death. There are also many sightings of a male phantom, believed to be White, gazing out of the second floor of the Gardner-Pingree House as the living frolic up and down Essex Street. If White's spirit truly has a calendar, his next scheduled appearance is April 6.

As for the city's penchant for historical coincidences also known as the "Salem factor," the family home of White's murderer, the Crowninshield-Bentley House, was literally moved next to the crime scene in 1959. Yep, the murderer's house was placed next door to the murder house. Sometimes fact is stranger than fiction.

File under: dark shadows

HAWTHORNE COVE MARINA

One tale from the crypt involves a salty sea captain spirit who yells, "Get out of here." It's this disembodied voice in the dark that spooked the late Robert Ellis Cahill, noted author of *Haunted Happenings* and a prolific folklorist responsible for putting a twist on much of Salem's storied ghost lore. "When I knew Bob, his thing was about debunking a lot of the supposed hauntings in Salem," recalled John Denley, founder of *Fright Times* magazine and long-time mastermind behind several haunted houses in Salem, including Witch Mansion on Essex Street. "People all over the city called him to check to see if their houses were haunted. However, there was one incident that really messed with him. It creeped him out so much he didn't want to talk about it."

The site? A two-story structure built by sea captain Herbert Miller from a salvaged barge at Hawthorne Cove Marina near the House of the Seven Gables. During the summer, the marina is the hub of Salem's

seaside activity. During the colder months, the location—formerly known as Miller's Wharf—is a virtual graveyard of winterized vessels with boats wrapped in protective tarps. There's also an ominous "private property" sign and a black dog that protects the two-story structure, which served as a "fish-food restaurant" back in the day. Cahill's friend Mike Purcell purchased the dwelling and said the previous owner recycled the hull of a barge and hoisted it up to create a second floor to what was his summer cottage. The building was rumored to have an odd energy to it, but Purcell couldn't figure out why, so he called Cahill. After some research, it turned out that the hull of the two-story structure was potentially a crime scene of a savagely butchered sea captain.

Hawthorne Cove Marina, formerly known as Miller's Wharf, reportedly has a negative energy of a murdered sea captain. It's speculated that the salvaged vessel converted into a summer cottage was possibly a barge called the *Glendower*, whose captain, Charles Wyman, was bludgeoned to death with an axe. *Photo by Andrew Warburton.*

Cahill didn't know much about the location in the '80s before hearing the voice that haunted him for years. It was a disembodied growl that came from nowhere: "Get out of here." Cahill described it as a "raspy, gurgling voice," and it spoke to him twice.

"There was no one else in the room and the voice had that eerie quality of coming from beyond the grave," wrote Cahill in *New England's Ghostly Haunts*. "I felt the heat of anxiety flood my face and body, but I didn't move."

Cahill was convinced the recycled barge was haunted but didn't know the history of the building when he published *Ghostly Haunts* in 1984. He called Herbert Miller's daughter, but she had no clue. It was years later that the barge's possible back story emerged, and it was more gruesome than Cahill could have imagined.

After years of research at the Salem Public Library, Cahill uncovered some shocking history that potentially linked the haunted barge to a horrific murder in 1911. It's speculated that the salvaged vessel was possibly a barge called the *Glendower*, whose captain, Charles Wyman, was bludgeoned to

death with an axe. He was whacked twenty-seven times according to the February 7, 1912 edition of the *Boston Daily Globe*. "Capt. Wyman was found lying face downward in his bunk. He was dead," reported the *Globe*. "His face and head were covered with cuts and bruises. Blood stains were on the walls and ceiling of the cabin, although there was no sign of a struggle."

Members of the crew, including an old Norwegian deckhand named Bill Nelson, were not covered in blood, and the murder became a "who done it?" of sorts. An investigation by the Boston police found that William De Graff, the *Glendower*'s hunchback cook, was possibly the murderer. One crew member testified that De Graff said that "Captain Wyman is no good," and the captain was axed to death at about 2:00 p.m., right after lunch. Prosecutors didn't have convincing evidence linking De Graff to the crime, and he was found not guilty thanks to the defense of noted attorney John Feeney. After the trial, the cook disappeared and was never heard from again. However, it's still believed the Dutch hunchback was indeed the culprit.

One spine-tingling piece of testimony echoes Cahill's haunted encounter at Miller's Wharf. According to the *Glendower*'s deckhand Nelson, he heard a muffled scream come from the captain's cabin around the time of the murder. Wyman's ominous last words according to Nelson's testimony? "Get out of here," he recalled.

Two years after the trial, a Philadelphia-based seaman claimed the Wyman murder was revenge. "De Graff had specifically gone to Newburyport from Philadelphia to join the *Glendower* crew as a cook, for the sole purpose of murdering Captain Wyman," said John Breen during an investigation in 1913. Apparently, Wyman had assaulted De Graff earlier in his career. "Wyman had physically flogged a young seaman out of the ship's rigging in a rage, causing him to fall to the deck, crippling him for life," Breen recalled. "The seaman was De Graff."

Cahill retold the story of the *Glendower* in his book *Haunted Ships of the North Atlantic* in 1997. During a public speaking event at Purcell's restaurant, a Salem-based surveyor, responsible for measuring the property around the wharf, approached Cahill and told him he had heard a similar disembodied voice growl those infamous four words: "Get out of here." Cahill was convinced. Mystery solved.

However, was the *Glendower*'s crime-scene hull truly used as Herbert Miller's summer cottage? After doing some research on the Wyman murder, *Ghosts of Salem* uncovered a series of newspaper clippings from the 1911 murder. There's one shot of jury members from the De Graff trial, wearing turn-of-the-century garb, walking the deck of the ill-fated barge. Oddly,

the pilothouse does look very similar to the current structure at Hawthorne Cove Marina.

"The barge, because of its horrid history, never went to sea again," wrote Cahill in *Haunted Ships*. "I think it was the barge that Herbert Miller purchased for pittance, towed to his wharf in Salem, some 12 miles away, and winched up to make a second story for his summer home. It is, I believe, the spirit of Captain Charles Wyman that haunts Miller's Wharf. His final words, shouted at the hunchback when he entered the captain's cabin with a concealed axe, are forever on his lips."

File under: haunted hull

Old Salem Jail

Salem's reportedly haunted correctional facility, which is believed to be the site of an estimated fifty hangings, has a long history of housing human monsters. Its lineup of usual suspects included Albert DeSalvo, more affectionately known as the Boston Strangler; hit man Joseph "The Animal" Barboza; former Mafia underboss Genaro Angiulo; and Brinks robber Joseph J. "Specs" O'Keefe.

Conditions in the old Salem Jail, which has oddly been refurbished into posh apartments, were notoriously horrific.

"It was a place that didn't have electricity or plumbing, even in the 1960s and 1970s," said Tim Maguire from the Salem Night Tour. "Atrocities happened there, more so than executions, and they would kill each other in the prison because the conditions were so unbearable."

The granite-walled jail and Federal-style keeper's house opened in 1813 next to the Howard Street Cemetery, where Giles Corey was crushed to death in 1692 over a torturous two-day period. The building was expanded in 1884, at which time its signature gothic, Victorian and mosque cupolas were placed on the roof. The building's addition was constructed with Rockport granite salvaged from St. Peter Street near the exact spot where Corey was pressed to death. Some believed the rocks used to build the jail were soaked with blood from the 1692 witch trials executions.

Almost 100 years after its expansion, conditions were so awful inside—inmates still had to use chamber pots for bathrooms—that a few prisoners successfully sued the county because of its inhumane living conditions. When it closed in 1991 after a 177-year run as a county jail, the Essex County Correctional

Conditions in the old Salem Jail, which opened in 1813 and expanded in 1884 were notoriously inhumane. When it closed in 1991 after a 177-year run as a county jail, it was considered the oldest active penitentiary in the United States. It's now a posh apartment complex. *Courtesy of the Boston Public Library.*

Institute or old Salem Jail was considered the oldest active penitentiary in the United States.

"We have left the dungeon behind us," said Essex County sheriff Charles H. Reardon at a ribbon-cutting ceremony for the new facility in Middleton in the 1990s.

But did they really? For more than a decade, the 31,630-square-foot jail ominously stood vacant. The boarded-up structure became a popular hot spot for vandals, and its historic facade started to look like a scene pulled from a Stephen King novel. It was during the '90s that the infamous correctional facility near the Howard Street Cemetery became the epicenter of Salem's ghost lore.

Based purely on aesthetics, the old Salem jail looked haunted.

"Many locals would go inside the jail and try to retrieve artifacts left behind," said tour guide Sarah-Frankie Clark. "It was common for people

to see shadow people inside and even outside on the grounds. It was an extremely active location, and people talked about feeling a heaviness in the air. The conditions were really bad there, so I'm not surprised."

The riots at the old Salem jail were legendary. In July 1980, six inmates turned the facility into a sewer after dumping waste buckets on the floors at the institution. When the prisoners were evacuated from the pre–Civil War facility in '91, they "threw food, lit trash cans on fire and threw urine-filled buckets throughout the jail," reported the *Salem Evening News*. One inmate wrote "we won" in toothpaste on a table in the prison's rectory. According to another newspaper report on February 21, 1991, the mess included "pizza boxes, clothing and food thrown about the jail. Also, windows and televisions were smashed and several walls kicked in."

The building became a "magnet for vandals just one year after Essex County leaders vowed to give it to the city," reported the *Salem Evening News* on August 15, 1997. "The 185-year-old building had again been vandalized and some copper piping stolen from it."

It became a hangout for thrill-seeking locals during the late '90s. "Kids have been getting in there and it's become a party place," said Salem police captain Harold Blake in the '97 newspaper report. "Someone's going to be liable if anything happens there, and I hope it doesn't fall on the city."

As far as spirits, people regularly heard whispers and "metal-like" sounds echoing throughout the structure when it was abandoned. There was also a residual haunting of what appeared to be a prisoner holding a candle and walking from room to room…on a floor that no longer existed and had collapsed years prior.

The jail grounds were extremely active, and several locals claimed to have seen shadow figures and full-bodied apparitions of former prisoners darting across the yard and heading toward the chain-link fence as if they were making their great escape in the afterlife. Civil War soldiers, who were imprisoned in the old Salem jail, were seen wearing nineteenth-century clothing and moaning in agony from war-related punishments. In fact, several prisoners who spent time at the Essex County Correctional Institute said they shared a cell with long-gone inmates, or "residents" as they were called in the '80s, from the Civil War era.

One explanation for the onslaught of so-called spectral evidence from the abandoned structure was that the living were reportedly coexisting with the dead. Yes, the jail had squatters. "People have been living in there for nine years," said former public works director Stanley Bornstein in the October 15, 1999 edition of the *Salem Evening News*. "You patch one hole, they open

another. Whatever you do, you're not going to keep people out of there. Somebody could easily be killed in there."

After the infamous penitentiary was turned into upscale condos and what was the sheriff's office became a popular St. Peter Street restaurant formerly called the Great Escape and now A&B Salem, the dark shadows from its past seem to have taken a break. Perhaps their torturous sentence behind bars extended after death, and once the cellblocks were removed and the space was transformed, the correctional facility's invisible prisoners were finally set free. Or the old Salem Jail's squatters—both the living and their spirited roommates—found a new home.

File under: prison break

Chapter 3

CURSED HAUNTS

If it's true that "what goes around comes around," Salem has endured more than three hundred years of torturous penance. Yes, lingering negativity associated with the city's Puritan forefathers continues to affect the city. "If you look at Salem's history, it has an amazing tradition of bad karma," explained historian Tim Maguire. "The wealthy of Salem made their blood money as privateers during the Revolution. Our history is tarnished with bad events and bad karma. I feel like the energy here is more negative than it is in other places. The witches in Salem call it the spirit of place."

When it comes to curses, a bulk of Salem's bad mojo can be traced back to 1692. There are two famous legends linked to the witch trials era that continue to haunt the city. First, there are the words supposedly uttered by Giles Corey, who was pressed to death over a two-day period. Before taking his last breath, he told the sadistic sheriff George Corwin, "I curse you and Salem." According to lore, Corey's spirit appears when tragedy is about to strike. In fact, several people claimed that the "old wizard," words used by author Nathaniel Hawthorne, appeared to several locals right before the great Salem fire of 1914.

Then there is the famous hex unleashed by Sarah Good, a thirty-eight-year-old, pipe-smoking vagabond who was executed as a witch on July 19, 1692. The object of her scorn? Reverend Nicholas Noyes. He was the assistant minister at First Church and lived on Washington Street just opposite accused Bridget Bishop's house. Noyes was actively involved in the

prosecution of many of the alleged witches and is known for calling the eight innocent victims dangling in Gallows Hill "firebrands of hell."

According to accounts, Reverend Noyes demanded a confession from Good, and Good, with a noose around her neck, called him a liar. "I am no more a witch than you are a wizard," she said. "And if you take away my life, God will give you blood to drink." Good had no way of knowing at the time that her words would come true, but ironically, Noyes did suffer from an aneurysm that caused blood to pour into his throat and out of his mouth. He literally choked to death on his own blood twenty-five years after Good was executed.

Salem homeboy Hawthorne alluded to Good's curse in his classic *The House of the Seven Gables*. In the book, witch trial character Matthew Maule curses his accuser, Colonel Pyncheon. Although historical record suggested that Good spewed her last words at Noyes, Hawthorne believed the venom was directed at his great-great-grandfather Judge John Hathorne.

As far as cursed locales, one Salem haunt had a ringside seat to the horrors of the witch dungeon, and many people suspect the structure contains residual energy, or a psychic imprint, from the era. Built in 1684, the John Ward House was moved to its present site behind the Gardner-Pingree House in 1910 and was later restored by the Essex Institute. Considered a highly active paranormal site by local investigators, the Colonial-style dwelling originally faced Prison Lane, currently called St. Peter Street, and was a stone's throw from the Giles Corey execution site. It stood literally across the street from the Witch Gaol.

Some believe those accused of witchcraft were taken to the wood-frame and clapboard structure to be stripped and searched for "witchery marks" or skin anomalies like warts or moles before being tortured emotionally and physically with needles and a bevy of seventeenth-century torture devices. For the record, family members of those accused were tortured as well. John Proctor, while waiting to be executed, talked about the interrogation of Martha Carrier's sons, who "would not confess anything till they tied them neck and heels and the blood was ready to come out of their noses," Proctor wrote.

While local taverns were mainly used for interrogations, some historians believe the Ward House was also a regular interrogation spot because of its proximity to the witch dungeon. As far as paranormal activity, employees of the Peabody Essex Museum (PEM) who use the historic house for storage claim to hear disembodied screams from the past, perhaps from the victims allegedly tortured there. Investigators and visitors have snapped photos

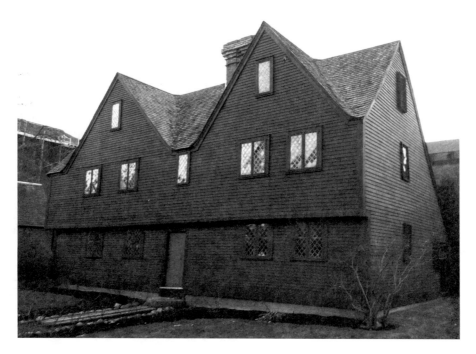

Built in 1684, the John Ward House was moved to its present site behind the Gardner-Pingree House in 1910. During the witch trials hysteria, it was literally across the street from the dungeon and is reportedly haunted by tortured spirits from Salem's past appearing as if they're begging for help. *Photo by Sam Baltrusis.*

through the windows of full-bodied apparitions of what appear to be frightened spirits begging for help.

Cursed? Perhaps. The John Ward House is one of many haunted hot spots in Salem with supposed ties to the deadliest witch hunt in American history.

ARMORY MEMORIAL PARK

If history repeats itself, then destructive fires are a recurring theme in Salem's cursed past. On February 22, 1982, the Salem National Guard Armory on Essex Street was destroyed by arson, and the nearby Masonic Temple building was severely damaged. "The fiery February was the worst Salem had seen since the epic fire of 1914," reported the *Salem News* in a retrospective article titled "A Nightmare Remembered."

Calling the five-alarm arson fire of 1982 a nightmare is an understatement. An earlier blaze, two days before the armory arson, claimed the life of Salem firefighter Raymond McSwiggin. The veteran collapsed at the scene on Washington Street.

Meanwhile, the police headquarters formerly on Central Street was mysteriously doused with gasoline while lit matches were found nearby. Fortunately, the arsonist couldn't ignite the gas. However, a state of emergency was declared throughout the city in the days leading up to the fiery grand finale. In early 1982, Salem was on edge.

"We were still feeling the loss of firefighter McSwiggin. While we were at the Armory [fire], we had the call about the Masonic Building. None of us had ever experienced that type of thing before," said deputy fire chief James Lynch in the *Salem News* report, adding that the fire was like a scene right out of a movie. "A very, very serious event in the history of the city went on that day."

After a massive investigation, officers arrested twenty-four-year-old Clement Lavigne, a local troublemaker with a history of criminal activity. Oddly, he stole items from the armory and kept them in a briefcase he carried around with him. Lavigne was found guilty and served time in prison.

Built for the Second Corps of Cadets in 1908, the castle-like structure on Essex Street was the go-to place for charity balls, political events and graduations. The armory also hosted professional wrestling matches and rock concerts. Presidents have visited the Salem National Guard Armory, including William Howard Taft on October 4, 1912. He dedicated a bronze tablet, and thousands, including 120 survivors from the Civil War, attended the ceremony.

On February 22, 1982, the Salem National Guard Armory on Essex Street was destroyed by arson. The armory's drill shed was salvaged after the blaze, and it was turned into the Salem Visitor Center in 1994. There are reports of a ghostly soldier guarding the structure. *Photo by Sam Baltrusis.*

Franklin D. Roosevelt made a campaign pit stop on November 1, 1933, and a crowd of more than five thousand gathered around the huge structure. During his speech at the armory, Roosevelt said he visited the city often when he attended Harvard. "How great it is to be back in Salem again," he said to the crowd of supporters.

The former drill shed was turned into the Salem Visitor Center in 1994, and the turreted structure was demolished six years later. The area in front of the center on New Liberty and Essex Streets was turned into Armory Park, a memorial honoring the veterans of Essex County. Vacant for almost twenty years, crews had a difficult time tearing down the armory's walls. Construction cranes continued to mysteriously shut down during the demolition process, and some believe the ghosts of the armory's vibrant past didn't want the decade-old structure torn down.

"There is a residual haunting of a soldier keeping guard at the armory," said Sarah-Frankie Carter, a Salem-based tour guide. "He's a non-interactive, full-bodied apparition walking back and forth as if he is protecting the former structure."

According to paranormal experts, the armory haunting is known as a spirit-level recording, or residual haunting, that replays over and over again like a videotape. "How and why past events are recorded and replayed repetitiously is not understood," speculated Lauren Forcella of the Paranormal Network. "Whatever the actual mechanism, it apparently possesses longevity as the encore performances of a haunting can continue for decades or longer. Generally, the haunting is a fragment or portion of an actual event."

Adam Page, a Salem-based investigator and former case manager with Paranormal Salem, said he's seen photographic evidence suggesting the area near the Armory Park is extremely active. "We've captured what looked like a modern-day soldier helping a girl cross the street," he said. "It's hard to tell what era this full-bodied apparition is from, but he looks fairly contemporary based on photos I've seen."

Page said that not all hauntings in Salem are linked to the witch trials or the fire disaster. "An energy can burn itself into a building, and it doesn't have to be negative," he continued. "It can be happiness. If someone felt safe at a certain location before they passed, perhaps their energy is imprinted into the stone."

As far as the ghost of the Salem National Guard Armory, it could be related to a recent declaration by President Barack Obama. On January 10, 2013, he signed an executive order designating Salem as the birthplace

of the U.S. National Guard. The country's early regiment of citizen soldiers, called the "First Muster," formed in the Salem Common in 1636. Volunteers from the Massachusetts National Guard gather annually on April 2 to pay homage to Captain Stephen Abbott, founder and first commander of the Second Corps of Cadets. He passed in 1785 and is buried at St. Peter's Church.

Every April, hundreds of soldiers commemorate the sacrifices made by their peers beginning with the American Revolution and continuing today with military operations overseas. Page described the uniform of the soldier spirit keeping guard in front of the former Salem Armory building. "Someone on one of the tours randomly took a photo outside of the armory, and there was a really clear picture of the soldier," he said. "We had our team look at the picture, and it was legit. Because I have a military background, they showed it to me. There were no patches on the uniform so we just assumed he was a marine."

After further investigation, the spectral soldier is wearing fatigues similar to the ones worn overseas in Afghanistan. "The man in the photo looks like he's contemporary," explained Page. "My instinct is that the soldier outside of the armory passed in combat overseas and has returned home in the afterlife."

File under: sentinel spirit

Joshua Ward House

Considered to be one of Salem's most haunted hot spots, the Joshua Ward House is currently on the market and selling for a mere $900,000. Room with a "boo?" Yep. It's a favorite stop for local ghost tours. In fact, many tour guides claim the Joshua Ward House is literally Salem's most active site.

Joshua Ward was a wealthy maritime merchant and sea captain. Originally, the house had a view of the South River, but in 1830, the Front Street waterway was filled in.

"The Joshua Ward House, on Washington Street opposite Front Street, was once symbolic of Salem's early prosperity," reported the *Salem Evening News* in 1979. "When George Washington visited the city in 1789, he asked to stay at the house, then only a few years old." For the record, the white statue peeking out of the building's second floor isn't a mysterious specter; it's a bust of our first president to commemorate his short stay in the city. Oddly,

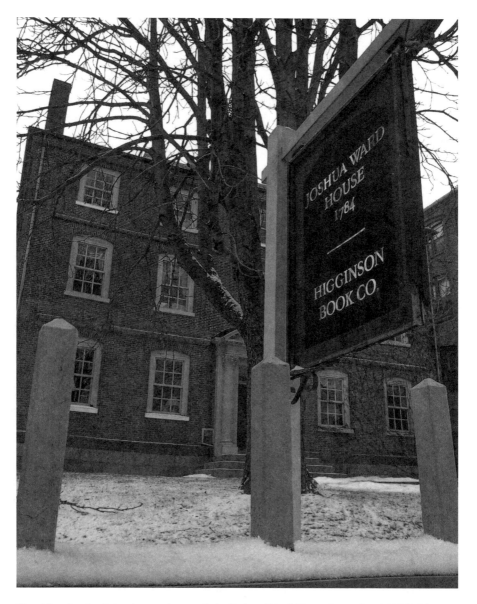

Considered to be Salem's most haunted, the Joshua Ward House located at 148 Washington Street was built on the foundation of Sheriff George Corwin's old house, and many believe his spirit lingers there. *Photo by Sam Baltrusis.*

Washington opted for late October when he visited Salem. Yep, he was two hundred years too early for the city's Haunted Happenings festivities.

Listed on the National Register of Historical Places in 1978, the three-floor Federal-style building had a stint as the Washington Hotel in the late nineteenth century. It stood vacant for years and was restored in the late '70s. When Carlson Realty moved into the historic house, mysterious events started to occur. Chairs, lampshades, trash cans and candlesticks would be found turned upside down when the staff arrived in the morning. Papers were strewn on the floor, and candles were bent in the shape of an "S." One of the offices on the second floor is ice cold, which is a telltale sign of paranormal activity.

Why would the Joshua Ward House be haunted?

The house was built on the foundation of Sheriff George Corwin's old house, and many believe the venerated sheriff's spirit lingers at the 148 Washington Street locale. In fact, his body was buried beneath the building but was later interred to Broad Street Cemetery.

Just to reiterate, Corwin was the sheriff of Essex County during the witch trials hysteria and was responsible for arresting and imprisoning over 150 accused innocents. He interrogated and reportedly savored torturing them. Also, he was known to confiscate all of the victims' possessions after they were imprisoned, and some were actually hanged at Gallows Hill.

When Corwin died shortly after the witch hysteria, he was buried in the basement. Because the man was so reviled by the locals, his family feared the angered townies would dig up his corpse and tear his body into pieces.

"Employees of Higginson Book Company relay stories of a female ghost sighted upstairs in one of the rooms," confirmed the *Salem Pioneer* in 1998. "Another sighting, that of the sheriff himself, was said to have been witnessed by another former book publisher."

The oddest piece of paranormal evidence was a Polaroid photo shot at the Carlson Realty holiday party in the '80s. According to lore, Carlson shot a photo of what was originally described as a light-haired woman enjoying the holiday festivities. What came out of the camera was something entirely different. It's a haggard woman, with translucent skin and frizzy black hair.

The creepy photo made its debut in Robert Cahill's book *Ghostly Haunts* in the '80s. Producers from *Unsolved Mysteries* picked it up, had the photo checked out for its authenticity and blasted it on national TV. The picture became local legend. Truthfully, the spooky snapshot looked like it could have been the later-identified subject, Julie Tremblay, standing in front of a holiday wreath. Contrary to local lore, Tremblay had dark hair.

In addition to the picture, there are many firsthand accounts of encounters with the witchy crone spirit. Cahill's sister-in-law told the author she saw the lady in black at the Joshua Ward House. "I immediately noticed a strange-looking woman sitting in a wingback chair across the hall in another office," she claimed. "The woman's skin didn't look like flesh, but was almost transparent like glass. She looked like a mannequin, just staring into space."

Then there is the report of visitors experiencing a choking sensation in George Washington's former room on the second floor. People have attributed this spirit to Corwin because of his notoriously sadistic approach to the witch trials victims. "All the lights were out and upon entering it my throat immediately tightened up," reported Cahill's assistant. "It was like someone was choking me. I was being strangled but I didn't feel any hands around my throat. Yet I felt my throat close up."

According to Cahill's theory, this sort of poltergeist activity would make sense. He claimed that Corwin was known as "the strangler" because of "his cruel method of torture used to gain confessions." However, there is little evidence to confirm that Corwin did, in fact, strangle his victims.

Based on anecdotal evidence, the entity at the Joshua Ward House doesn't like men. It seems that women actually see the lady in black, and men are often attacked, whether it's inexplicable scratch marks on their chests or the overwhelming sensation of being choked when entering the same second-floor room.

The building's porter claimed to have been grabbed from behind by an unseen force. "I could feel the hand on my shoulder, weighing me down," he told Cahill. "When I turned around, nobody was there."

Many believe the Joshua Ward House ghost is one of the women Corwin wrongly arrested and tortured. Yes, she's seeking postmortem revenge.

File under: phantom menace

ROPES MANSION

When it comes to the fire-prone Ropes Mansion, fact is stranger than fiction. The ghost lore associated with the 1720s-era Georgian Colonial home involving Judge Nathaniel Ropes and his distant relative Abigail Ropes has been twisted over time. However, it doesn't mean the Samuel McIntire–designed mansion isn't inhabited by the spirits of its previous owners.

Ropes Mansion, 318 Essex Street, is believed to be haunted by Judge Nathaniel Ropes and his distant relative Abigail Ropes. Ghost lore enthusiasts claim that Ropes's "stay behind" spirit is responsible for the freakish fires plaguing the 1720s-era Georgian Colonial home. *Photo by Sam Baltrusis.*

Known for its beautifully curated gardens and brief-but-memorable cameo in the Salem-based flick *Hocus Pocus*, the Ropes Mansion has a haunted history dating back to 1774 when the Tory-leaning Judge Ropes was mobbed by a gang of Patriots who hurled mud and stones at the house. The revolutionaries wanted the judge to publicly denounce his loyalties to the British crown. Ropes didn't respond from his bedchamber, and the forty-eight-year-old died the following day from complications associated with smallpox.

Judge Ropes's spirit reportedly still lingers in the white, eighteenth-century house. In fact, the mansion's former caretakers Rick and Georgette Stafford snapped a photo during an insurance appraisal of what looks like two ghostly hands of a man sitting on the couch in the front hall. Oddly, it's in this spot where Ropes and John Adams argued politics over lunch in 1769. Author Robert Ellis Cahill published the now-infamous picture in his book *Ghostly Haunts*. "Here the judge sits for a spell on the front hall couch," Cahill

wrote. "After all, if you were wandering around this mansion for 200 years, you'd want to sit for a while, wouldn't you?"

In *Ghostly Haunts*, the Staffords alluded to a recurring issue plaguing the twenty-room mansion: fire and the lingering energy of Abigail "Nabby" Ropes. "The burglar or fire alarm would go off now and then, bringing the police or fire trucks," Stafford said. "Occasionally, a dish would be knocked over in the pantry late at night, but otherwise, the Judge and Abigail have been fairly quiet."

The Staffords were featured in an article in the 1980s, and the piece talked about the lore associated with the ghost of Nabby. "At sunset, Georgette works her way upstairs to draw in the Ropes family flag hanging above the front doorway," wrote journalist George Harrar. "There in the blue room she listens a moment for the screams of Abigail Ropes, consumed by fire when her petticoats caught flame at the fireplace. Abigail's servants never heard the screams for help, or so they said."

Several sources including *Haunted Salem & Beyond* incorrectly identify Abigail's ties to the house's original owner. "Judge Ropes's wife Abigail also died in the house. Hers was a bizarre and tragic passing."

Not true. After digging through historical documents, it turns out that Judge Ropes's wife was Priscilla Sparhawk Ropes. However, it's true that Abigail's death was bizarre and tragic. Born on October 20, 1796, she was the daughter of a later Nathaniel Ropes and his first wife, Sarah. "She died unmarried from burns received when carrying coals from one room to another," confirmed *Portraits in Public Buildings in Salem* memorializing her death on April 23. Nabby's obituary published in the April 26, 1839 edition of the *Salem Gazette* offered more details, reporting that she suffered from "a distressing illness of three weeks caused by her clothes accidentally taking fire."

Yes, Abigail Ropes, who received the nickname "Nabby" from her family, became a human torch and burned alive in the mansion's second-floor blue room. Her horrific demise, spanning three weeks, might explain the reports—ranging from a ghostly figure peeking out of the second-floor window to sightings of a full-bodied female apparition with long, dark hair wrapped in a bun—of supposed paranormal activity linked to the home.

In her obituary, she was portrayed as a recluse: "Though mixing little in general society, she was interested in all the passing events in life." In other words, she didn't leave the house much.

However, is her poltergeist responsible for the freakish fires plaguing Ropes Mansion?

While workmen were renovating the structure's exterior on August 18, 2009, a heating gun used to remove paint mysteriously ignited and destroyed the third floor and attic of the historic home. The first and second floors were also damaged by water and smoke. Fortunately, only one item from America's largest Chinese porcelain collection was damaged. Out of the three hundred valuable pieces, only a glass pitcher from the late 1800s shattered. Also, Nellie S. Messer's article on the mansion talked about fires happening in the late 1800s after Abigail Ropes died tragically.

It's a recurring theme for "stay behinds," or spirits that don't know they're dead, to cause an uproar when their beloved space is being renovated. Ghosts, especially homebound spirits emotionally attached to their surroundings, don't like change. In fact, it's common for bizarre mishaps, from a heating-gun fire to a mysteriously falling ladder, to disrupt the renovation process of allegedly haunted locales. It would make sense for Ropes's spirit to make a postmortem plea to keep her mansion in the same condition she left it in 1839.

Reports from tour guides suggest that the Colonial Revival–style garden behind the house is also haunted. Visitors claim to hear disembodied whispers and the occasional tap on the shoulder when no one is there. One gentleman, Andy Bye, was the main gardener for fifty years, from 1931 to his passing in 1994.

It's believed the energy in the garden is a residual haunting. However, it could be the reclusive Abigail Ropes taking a rare stroll outside of the mansion she loved so much. In an attempt to communicate with the garden's visitors, it's believed that it's her icy-cold hands tapping visitors from behind and begging for recognition among the living.

File under: Nabby's nightmare

SAMUEL PICKMAN HOUSE

The history surrounding the Pickman House, located on the corner of Charter and Liberty Streets, is almost as bizarre as the ghost lore associated with the Colonial-era structure. After attending a lecture series in the early 1960s, local Elizabeth Reardon uncovered this historical gem wrapped beneath the façade of a Victorian mansard roof. After doing some research, it turns out the wood-frame and clapboard structure believed to have been built in 1664 is one of Salem's oldest buildings.

It's also potentially one of the city's most haunted.

Nestled next to the highly trafficked Charter Street Cemetery, the building is now owned by the Peabody Essex Museum. Tour groups pass this historic building, and passersby peek through its windows. Several people believe they've seen a full-bodied apparition of a girl peering from the upper-floor window. Others claim the small Samuel Pickman House is home to a demonic entity that manifests in photos taken through the seventeenth-century building's old-school windows.

One ghastly story tells of a husband and wife who lived in the Samuel Pickman House with their seven-year-old daughter. Similar to the demonic infestation in Stephen King's *The Shining*, an evil entity is rumored to have caused the husband to go insane.

According to legend, the man chained his daughter up in the attic, torturing and starving the child. He then tied his wife to a tree outside and killed her by pouring hot wax over her body, leaving her to die a slow, painful

The Samuel Pickman House, located on the corner of Charter and Liberty Streets, is said to be home to an evil entity connected to a horrific murder committed centuries ago. There are reports of the ghost of a young girl looking out the attic window at the crowds below. *Photo by Sam Baltrusis.*

death. The possessed man then fled, leaving the dead child in the attic and his murdered-by-wax wife tied to the tree.

People on my Salem Witch Haunts tour who have taken photos of the house claim it is still inhabited by a demonic force. There are many reports of the ghost of the young girl looking out the attic window at the crowds below.

After doing exhaustive historical research, I found no real proof to suggest that the story of the murder or the supposed demonic infestation at the house is true. However, the building is a surefire hot spot of photographic anomalies, ranging from orbs to a mist that envelops the structure.

Nick Groff, a pop-culture investigator from the Travel Channel's *Ghost Adventures*, talked about his experiences with negative spirit attachments. "Positive and negative energies really do exist and they can have a major effect on you and your well being," Groff told *Ghosts of Salem*. "If something is going to attach itself to me after leaving a negative location, it's difficult to get rid of that energy when you go home. Mentally, I try to stay strong and eventually it depreciates. It goes away."

The TV investigator continues: "Sometimes certain situations take longer than others, but I try to close the door when I leave a location. I just block it out. If you don't, it tends to feed on negativity, and it intensifies when you go home."

Whether the Pickman House horror story is true or not, one case from the seventeenth century has some striking similarities to the tall tale and an equally shocking ending.

Puritan woman Dorothy Talbye went from being a respectable member of Salem's church to a despondent and increasingly violent murderess. Her husband complained of her bizarre behavior to Salem authorities, who sentenced her in 1637 to be chained to a post for "frequently laying hands on her husband, to the danger of his life."

Governor John Winthrop wrote about Talbye's mental and behavioral maladies, including "falling [into] difference with her husband," a host of "melancholy or spiritual delusions," threats to kill her husband and, ultimately, the crime of infanticide.

Talbye was hanged in December 1638 for killing her three-year-old daughter, whom she'd named "Difficult." According to her testimony, God had told her to murder her daughter. Winthrop, the governor of Massachusetts Bay Colony, believed Satan had possessed Talbye. Modern-day therapists believe she suffered from a severe case of postpartum depression.

The woman broke her daughter's neck on a cold October night in 1638. At her trial, Talbye refused to speak until Winthrop threatened to pile stones

on her chest. During her execution, she fought to the bitter end. With the noose around her neck, she ripped off the cloth around her head and put it under the noose to ease the pain. She also made an attempt to grab the ladder. No luck. Talbye was hanged.

Demonic possession? Perhaps. In both the Talbye murder and the alleged Pickman House infestation, the negative energy associated with each case has ties to unspeakable acts of violence. Puritans believed evil was present and active in Salem.

However, does the darkness linger? Many claim the horned man hides in the shadows of Salem's historic haunts plotting his sinister return.

File under: resident evil

HAWTHORNE HAUNTS

D id Salem-bred Nathaniel Hawthorne, author of the classics *The Scarlet Letter* and *The House of the Seven Gables*, believe in ghosts? Based on the themes he explored in his books, the iconic author may have, but he definitely had a healthy dose of skepticism.

His friend William Baker Pike worked with Hawthorne at the Salem Custom House in the 1840s. Pike, a Swedenborgian spiritualist, strongly believed in the idea of communicating with the dead. However, the author initially had his doubts. "Hawthorne was a skeptic, but he treated Pike's belief with respect," wrote Margaret Moore in *The Salem World of Nathaniel Hawthorne*.

In fact, Hawthorne wrote about his skepticism in a letter to Pike dated July 24, 1851. "I should be very glad to believe that these rappers are, in any one instance, the spirits of the persons whom they profess themselves to be; but though I have talked with those who have had the freest communication, there has always been something that makes me doubt."

While Hawthorne was initially a skeptic, he started to explore the possibility of the existence of spirits in his fiction. His book, *The House of the Seven Gables*, hinted at the supernatural with one character, Alice Pyncheon, being driven mad by a spell and dying from shame. Her spirit haunted the gabled house. Also, the building's original owner, Matthew Maule, makes a postmortem return to his ancestral dwelling in the novel.

Hawthorne's skeptical tune changed later in his life. In a story written in hindsight and published posthumously, the author claimed that he had a

Literary icon Nathaniel Hawthorne, author of *The Scarlet Letter* and *The House of the Seven Gables*, had a love-hate relationship with his hometown. After penning his famous fictional account of New England's Puritanical past, he left Salem for good in late 1850. *Courtesy of the Boston Public Library.*

close encounter with a haunting while hanging out at the Boston Athenaeum, a members-only research facility considered to be the nation's oldest library, founded in 1807. It was a private gentleman's club, hosting luminaries such as Henry Wadsworth Longfellow, Henry David Thoreau and, of course, Hawthorne, who read books and shared ideas.

Yes, it was a gentleman's club—no, not that kind of gentleman's club.

According to his published account called *The Ghost of Doctor Harris*, the famed writer in residence was eating breakfast one morning at the library's former Pearl Street location when he noticed a familiar face reading the *Boston Post*. It was Dr. Thaddeus Mason Harris, a well-known Unitarian clergyman from Dorchester, sitting in his usual chair in front of the library's second-floor fireplace. Hawthorne didn't bother the old patriarch. However, he was shocked to learn later that night that the Athenaeum regular had passed away.

Hawthorne returned to the Athenaeum the following day and noticed, completely in shock, Harris sitting at his usual spot and reading the

newspaper. Yep, Hawthorne spotted the deceased doctor, looking "gaseous and vapory," and he was completely dumbfounded.

According to lore, Hawthorne spotted Harris's ghost for six weeks, and he later told his editor that he wished he had confronted the apparition. He wanted to ask him, "So, what's it like to be dead?" or at least find out if the old man knew he had passed. In fact, Hawthorne joked with his editor about the Harris encounter, saying, "Perhaps he finally got to his obituary and realized he was dead."

For the record, several books on Salem's ghost lore, including Robert Ellis Cahill's *Ghostly Haunts*, claimed that Hawthorne's encounter with Harris was at the Salem Athenaeum. Not true. While the author frequented Salem's private library to learn about his familial ties to the 1692 witch trials hysteria, his run-in with the old-man spirit was in Boston.

Currently located at 337 Essex Street, the Salem counterpart of the private library was moved around during Hawthorne's lifetime. After

Books on Salem's lore, including Robert Ellis Cahill's *Ghostly Haunts*, claimed that Hawthorne's encounter with the ghost of Reverend Harris was at the Salem Athenaeum. Unfortunately, the sighting was at Boston's exclusive library formerly on Pearl Street. *Photo by Sam Baltrusis.*

studying at Bowdoin College in Maine, Hawthorne returned to Salem in 1825. Hawthorne frequented the 34 Front Street location between 1841 and 1857, as well as the second floor of Plummer Hall, which is now the Phillips Library owned by the Peabody Essex Museum.

Whether Hawthorne actually believed in ghosts or merely used paranormal manifestations as a metaphorical device is a mute point. He was an inspiration for future writers, including horror author H.P. Lovecraft, who called *The House of the Seven Gables* one of "New England's greatest contributions to weird literature." It's believed that Lovecraft's short stories "The Shunned House" and "The Picture in the House" were inspired by *Seven Gables*.

Even though he spent a majority of his youth in the North Shore city, Hawthorne mused that he was "invariably happier elsewhere." In fact, he and his family moved to a remote cottage in western Massachusetts after a scandalous three-year stint as a surveyor at Salem's Custom House. After writing what is viewed as a negative depiction of Salem in the introduction of *The Scarlet Letter*, he traveled throughout the Boston area, returning to Salem only a handful of times in the last fourteen years of his life.

During a book tour in Plymouth, New Hampshire, Hawthorne died in his sleep. Even though he was buried in an area known as "Author's Ridge" in Concord's Sleepy Hollow Cemetery, Hawthorne's spirit lives on in Salem.

More than 150 years after his death, his ghosts continue to haunt the city he both loved and loathed.

CUSTOM HOUSE

There's no denying that Salem's native son Nathaniel Hawthorne left his imprint on the city. In the introductory chapter of his famous novel of betrayal, *The Scarlet Letter*, Hawthorne described finding the scarlet "A" that inspired his tale in a spare room of the Custom House when he worked there as a surveyor between 1846–49.

Hawthorne was evasive when journalists asked him to produce the famous scarlet "A" and later said one of his children dropped the infamous red letter into a fire.

Whether Hawthorne's tale was true or not, the Custom House, which was built in 1819, continues to be a hot spot for tourists visiting Salem. There's a carved wooden bald eagle, painted gold, that sits atop the

Built facing Derby Wharf in 1818–19, the Custom House continues to be a hot spot for tourists—and sea captain spirits—visiting Salem. Hawthorne's stint as surveyor of the port inspired the introduction to *The Scarlet Letter*. *Photo by Sam Baltrusis.*

Custom House, alluding to the historic building's heyday in the early 1800s, when custom duties, not income taxes, were the primary source of government revenue.

An oil painting of Elias Hasket Derby Sr., the country's first millionaire, hangs above the desk where Hawthorne worked. His view from the office space is the historic Derby Wharf, which was extended to its current length of more than one mile in 1806. Work on the wharf started in 1762 by its wealthy namesake.

Both the Custom House and the Derby Wharf are allegedly teeming with the spirits of Salem's maritime past, ranging from ghostly pirates mysteriously emerging from the water and walking around to salty sea captains whispering in the Custom House about their treasures smuggled in from overseas.

Shipbuilding flourished in Salem. By 1750, the city's commerce was enmeshed with the sea, and brazen sea captains sailed their ships to the West Indies and traded lumber and fish for sugar and molasses. During the

Revolutionary War, Salem was the country's primary seaport because the British had barricaded Boston and New York. By 1820, with the exception of the embargo during the War of 1812, Salem was flourishing and fast-sailing ships were built for trade with China and India. Pepper and spices were brought back and sold for an enormous profit.

There was also a lot of seediness going on during this era, and many of the ghosts supposedly haunting the Custom House and Derby Wharf are tied to the darker side of Salem's golden maritime era.

Pirates? Yep, Salem had them. However, they were given a less disparaging title. They were called "privateers." Of course, the Derby Wharf area has a few pirate ghosts looking for their long-lost booty.

So, how did the so-called privateers smuggle the goods past the custom agents? One theory is that Elias Hasket Derby's son built a series of underground tunnels in 1801 connecting the wharf and various homes and buildings scattered throughout downtown Salem. Christopher Dowgin, author of *Salem Secret Underground*, weaved together a convincing history of the city's tunnels. "From the various wharfs, goods were smuggled through trap doors into the tunnels that led to the merchants' and ship captains' homes," Dowgin wrote. "There the goods were stored till they moved them to their stores on Essex Street."

Speaking of the tunnels, many believe these secret underground passageways are haunted. Dowgin talked about one spooky incident near Blaney Street. "I just barely lifted my cell phone from its case on my belt when the phone flew twenty-five feet into an open manhole," he commented, adding that the batteries of electronic devices mysteriously drain and orbs show up regularly in photos near the wharf.

Visitors who are sensitive to the paranormal often report seeing full-bodied apparitions of salty seafarers walking aimlessly around Derby Wharf. Others claim to have heard footsteps when no one is there. Cold spots on warm summer days, an indication of paranormal activity, are the norm near the lighthouse at the end of the wharf. One woman felt an icy tap on her shoulder and spotted what looked like an 1800s-era fisherman who immediately disappeared when she turned around.

The scene inside the Custom House is said to be equally active. While tour guides are notoriously tight-lipped about the structure's supposed hauntings, visitors have heard disembodied footsteps echo throughout the brick Federalist-style building. There are also reports of inexplicable, flickering lights emanating from within the Custom House that disappear when people approach them.

So, did Hawthorne believe the Custom House was haunted? Probably not.

Several writers opined that the *Scarlet Letter* writer was creeped out by the building's spirits. "Maybe Hawthorne knew a bit more about the place than he let on," wrote Thomas D'Agostino in *A Guide to Haunted New England*. Based on historical research, there's no concrete proof he had a close encounter there. In fact, during his stint at the Custom House the author expressed more skepticism than belief in the existence of paranormal activity. However, he did write about spirits in his books, specifically *The House of the Seven Gables*, later in his career.

As far as the pirate ghosts spotted on the Derby Wharf, one theory is that they're residual hauntings, or a videotape replay of the maritime action back in the early 1800s.

Another possibility could be related to a tragedy involving a deadly close encounter at sea on March 6, 1869. During a torrential storm that eventually became a hurricane, a Salem-based schooner known as the *Andrew Johnson* had a fatal collision with a so-called hoodoo ship named the *Charles Haskell*.

Derby Wharf, built in the early 1700s, is supposedly home to pirate ghosts. In fact, one woman felt an icy tap on her shoulder and spotted what looked like an 1800s-era fisherman who immediately disappeared when she turned around. *Photo by Sam Baltrusis.*

Apparently, the *Haskell* had a history of bad luck. In fact, one workman slipped on board and broke his neck. Also, its first captain quit before the ship's maiden voyage because he believed the vessel was cursed.

According to accounts from the *Haskell*, the schooner rammed into the *Andrew Johnson* during the hurricane and ripped it into pieces. The *Johnson* was literally sliced open. The surviving ship's crew witnessed their peers frantically trying to stay alive. The vessel and its ten men were engulfed by the thrashing sea.

One legend gives an alternative to the spirits haunting Derby Wharf. According to *Weird Massachusetts*, the night watchmen on the *Haskell* encountered similar phantoms on board several days after they witnessed the *Johnson* sink into its watery grave.

"They saw dark, shadowy figures rising out of the sea," wrote Jeff Belanger. "There were ten of them in all, and as they reached the *Haskell* the watchmen could see that the figures looked like men. The dark wraiths reached their hands over the rail of the schooner and climbed aboard. Their eyes were black, like hollowed-out holes, and they wore dark and oily sealskins for clothes. The phantoms quickly took up positions around the ship and began to go through the motions of casting lines, rigging sails and setting the anchor."

Perhaps the ghostly seafarers regularly spotted on Derby Wharf are the casualties of the ill-fated *Andrew Johnson*. It's said that the crew was never to be seen or heard from again—at least, not among the living. Maybe the men have finally made it home after being lost at sea for almost 150 years.

File under: salty specters

GALLOWS HILL

Where in Salem is Gallows Hill? No one knows for sure. However, Nathaniel Hawthorne would notoriously take regular walks to the location where nineteen innocents were hanged for witchcraft in 1692. "Mornings he devoted to writing," wrote Milton Meltzer in *Nathaniel Hawthorne: A Biography*. "In the afternoon when the weather was good he took long walks, sometimes to Gallows Hill."

The condemned were taken by a two-wheel oxcart from the Witch Gaol at 10 Federal Street, down present-day Essex Street to their final destination. According to lore, the location of the site was passed down from one

Where in Salem is Gallows Hill? Historians aren't sure of the exact location nineteen men and women were hanged in 1692. However, the latest theory is that the true site is a rocky, wooded area behind the Walgreen's located at 59 Boston Street. *Photo by Sam Baltrusis.*

generation to the next. In *Alice Doane's Appeal*, Hawthorne described visiting the tragic spot in the 1800s. "This was the field where superstition won her darkest triumph," he wrote. "The high place where our fathers set up their shame, to the mournful gaze of generations far remote. The dust of martyrs was beneath our feet. We stood on Gallows Hill."

Unfortunately, he didn't mention the exact location, an issue that has stumped contemporary historians for years. Some believe the hangings were so horrific that locals wanted to completely close the door on one of the darkest chapters from the Colonial era. "So long buried was Salem's memory of the witch trials that no one is entirely sure where the accused witches were executed," wrote historian Richard Trask in his essay *The Witchcraft Trials of 1692*. "The city maintains a park at the most likely site, above the area known as 'Blubber Hollow.'"

Most believe the bodies of the innocent were thrown in a shallow ditch at what is now a playground outside of downtown Salem called Gallows Hill Park. The city acquired the site in 1912. The issue surrounding the exact

location of the gallows resurfaced in 1998 when the city announced plans to build a school at what was believed to be the execution site. "There has been, for at least 90 years, a link in the community between the hangings and that site," said Liz Griffin in the March 23, 1998 edition of the *Salem Evening News*. "When the city—back in the late 1800s—started looking at that land, the original purpose was to buy a small piece of that land to put up a monument to commemorate the tragedy."

Salem's city council set aside money in the 1890s to buy "witch square" on Gallows Hill, a spot near the top of the park where people believed the hangings took place. However, one local historian, Marilynne Roach, challenged the historically accepted spot in 1997, claiming that the nineteen men and women killed in 1692 most likely were hanged on the "lower ledges" of Gallows Hill or the public wooded land between Proctor and Pope Streets.

"There isn't an 'X marks the spot,'" said Roach in a report, adding that it continues to be "a mystery of many theories and few clues."

One piece of new evidence emerged from court notes dating back to August 1692. Rebecca Eames, a woman suspected of witchcraft who was taken from her home in Boxford, said she saw the gallows from Boston Street while on her way to downtown Salem. The latest theory is that the true site is behind the Walgreen's located at 59 Boston Street.

Paranormal investigators suggest that the ghosts of Salem's witch trials past can assist the living in their efforts to pinpoint the hangings spot.

Mollie Stewart, a former tour owner of Spellbound who has relocated to New Orleans, encountered a presence when conducting an investigation near the "lower ledges" of Gallows Hill. "As Mollie ventured up the hill, she at first didn't think too much of it when she heard voices," recounted Leslie Rule in *When the Ghost Screams*. "She figured it was just a few other people, out exploring. But then she spotted a hooded figure. As she stared, it vanished before her eyes."

Eric Fiahlo, a Witch House tour guide who was recently featured on the History Channel 2's documentary focusing on a handful of Salem's alleged haunts, said he had an encounter during an electronic voice phenomenon (EVP) session a few years ago.

"I was with a couple of friends, and we took a recording device with the hopes of capturing a voice," he said. "We came to the base of the hill. One of the questions we asked was 'are you a condemned witch?' and we picked up a distinct 'no.' We got out of there as quick as we could," he said, pointing to a specific location in Gallows Hill Park where he thought the nineteen victims were executed. Oddly, it was next to the playground with swings. "It

was a very slow, slow death," Fialho continued. "They would spin off the ladder and strangle to death. It's certainly a gruesome way to go."

In an interview with *Ghosts of Salem*, Fialho said producers from the History Channel pressured him to give an exact spot where Gallows Hill is supposedly located. "Truthfully, we don't really know where it is," he said in hindsight. "There are so few clues."

Tim Maguire from the Salem Night Tour said he's heard tons of stories associated with the area around Gallows Hill Park. "There have been several suicides," said Maguire. "Inexplicable stuff has happened there over the years."

Maguire alluded to reports of full-bodied apparitions and phantom voices. He also talked about a series of self-inflicted deaths. In 2008, a man was found hanged from a tree near the city's water tank. Officials said it "appeared to be a suicide at the time," adding there were no signs of foul play.

As far as how they were executed, historians aren't sure if the actual hangings were on locust trees, which were probably not strong enough for an execution, or if the accused were hanged from traditional gallows. "Contemporary accounts make clear that the prisoners uttered their last words, with nooses around their necks, from ladders," wrote Frances Hill in *Hunting for Witches*. "When the ladder was pushed away from whatever it was leaning on, they died a slow, painful death. But whether the ladder was supported by a branch or a scaffold, the sources do not say."

There is also debate about the skeletal remains of the victims. "Bone fragments have been found," said a representative from the Peabody Essex Museum about an excavation at Gallows Hill Park, "but we'll never really know what they were from." At least three victims from 1692—Rebecca Nurse, John Proctor and George Jacobs—were brought back by relatives, salvaged in the wee hours of the night and given a proper burial. The remains of the other sixteen victims, which have been the subject of rumors that they were exhumed and relocated by wealthy merchant Phillip English and other theories claiming they were buried beneath the cellar of a church in nearby Marblehead, are believed to be dumped in either a ditch or within the rocky crevices surrounding Gallows Hill Park.

Based on ghost lore, hauntings have been associated with the lack of proper burial or a later desecration of the grave. Countless spirits, according to paranormal researchers, have been traced to missing gravestones or vandalism of a resting place. Perhaps the spirits reported wandering the Gallows Hill area are making a postmortem plea for a proper burial.

File under: gallows ghosts

HOUSE OF THE SEVEN GABLES

When asked about the alleged hauntings at the Turner-Ingersoll Mansion, tour guides with the House of the Seven Gables are quick to dispel the rumors. "Nope, haven't heard of any ghosts," remarked one veteran tour guide walking a large group up the now-famous secret staircase to what is believed to be the structure's haunted attic. Another guide merely said that the house "can get creepy at night."

Meanwhile, the eyes of the Victorian-era paintings dotting the beloved inspiration for Nathaniel Hawthorne's Gothic masterpiece, *The House of the Seven Gables*, eerily seem like they're following the group as the tour quietly shuffles from one room to the next.

No way. It's not haunted. Or is it?

Several books on ghost lore list the Turner House as one of Salem's most active. However, some of the information is based purely on conjecture. "Nathaniel Hawthorne, descendent of one of the witchcraft judges, was born in Salem in 1804 and always felt that the home of cousin Susan Ingersoll was haunted," wrote Dennis Hauck in *Haunted Places*. "He put his impressions on paper in the famous horror novel whose name the house now bears. The House of the Seven Gables is considered to be one of the eeriest in a town full of haunted houses."

Other stories suggest that Ingersoll, who inherited the house from her ship captain father after John Turner III lost the family fortune, has been spotted roaming the house's hallways. According to reports, she eerily peeks out of the windows when visitors are frolicking in the museum's beautifully manicured gardens. Yes, she's supposedly keeping watch over the droves of people touring her former home.

Another tale involves a boy ghost who plays in the Turner House's attic. The sounds of disembodied footsteps and laughter have been heard in the top floor when no one, at least among the living, is up there. Oddly, the attic is where the Turner family's servants slept. Re-created sleeping quarters are visible when touring the house, and one room, located under one of the top floor's gables, is armed with a child's rocking chair and sleeping mat. Perhaps this is where the boy specter plays.

Also, there's a blog post circulating online about a close encounter with what is believed to be the ghost of Hawthorne's son, Julian, peeking over a fence in the garden. "I decided to take a guided tour of the House of the Seven Gables property, also known as the Turner-Ingersoll Mansion located at 54 Turner Street," wrote Lisa from Long Island. "On

Tour guides with the House of the Seven Gables are notoriously tight-lipped about the spirits reported to linger in the Turner-Ingersoll Mansion, including rumors of the former owner eerily peeking out of the windows when visitors are checking out the museum's manicured gardens. *Courtesy of the Boston Public Library.*

that property now sits the birth home of American author Nathaniel Hawthorne, which was actually moved from Union Street onto Turner Street." The woman shot a photo of what looked like a boy or, as others have suggested, a smudge on her camera lens or a wayward squirrel. The editor used an archival photo of Hawthorne's son to positively identify the so-called paranormal photo.

For the record, neither Hawthorne nor his son ever lived in the Turner House.

There is also lore associated with the secret staircase, built in 1908, which leads visitors to the attic, which is rumored to be haunted. According to several reports, people have witnessed the phantom of a man believed to be a slave trekking up and down the stairs. Some say that the Turner House, which was originally much smaller with only two-and-a-half floors, was an end stop on the Underground Railroad. However, the hidden steps were built almost fifty years after slavery was abolished. So it's highly unlikely it's a residual haunting of a slave.

Philanthropist Caroline Emmerton founded the present-day museum and created the staircase with the help of architect Joseph Everett Chandler in

1908. Yes, the stairs are creepy, and the journey to the attic can be a tad claustrophobic. But the hidden passageway is probably not active.

Then there is the final stop on the tour, Hawthorne's birthplace, which was moved from Union Street to its present-day location next to the Turner House in 1958. This modest Georgian-style structure is definitely more eerie than its supposedly haunted neighbor. According to Lynda Lee Macken's *Haunted Salem & Beyond*, a seamstress ghost inhabits the house. "Her spirit has been seen sewing and walking in the house," Macken claimed.

Based purely on lore, the House of the Seven Gables is home to five ghosts—and a handful of living tour guides who vehemently deny their existence.

But is it really haunted? Paranormal investigators haven't yet had access to either the Turner House or Hawthorne's birthplace. Only anecdotal evidence exists so far.

However, Adam Berry from *Ghost Hunters* told me to rely on one's intuition when checking out spots with alleged paranormal activity. "As investigators, we try not to go on feelings, because you can't prove feelings," Berry said. "But you can't ignore your biggest organ, which is your skin and the goose bumps that you get and feeling like you're being watched."

There is definitely a sensation of being watched when walking in the museum's gardens. The Turner House's attic, said to be haunted by a young boy, did have a residual-energy vibe to it. During one visit on a particularly windy day, the wooden gates mysteriously opened and closed for my skeptical assistant when he left the property. Also, the eyes of the paintings scattered throughout the house did seem like they were following our tour group as we moved from room to room.

Haunted? Probably not. In fact, there's a whole section in Tom D'Agostino's *A Guide to Haunted New England* trying to convince readers that the House of the Seven Gables is free of ghosts. "I must note for posterity that some claim to have seen spirits in the house, but the staff has never witnessed anything unusual," wrote contributor Amy Waywell. "A haunting can be in the imagination of the beholder or sitting in the wings waiting for the right people."

File under: ghost busted

Chapter 5
NIGHTLIFE HAUNTS

S alem boasts a motley crew of nightlife locales rumored to be stomping grounds for spirits—and not the kind that come in a chilled martini glass. The list includes a bevy of atypical haunts, ranging from a former Prohibition-era funeral parlor to Salem's independent movie theater to a restaurant in Salem's refurbished old jail located next to the allegedly haunted Howard Street Cemetery. Apparently, the living aren't the only things that go bump in the nightlife.

Historically, Salem's watering holes were gathering places for seventeenth-century troublemakers and were, in essence, "nerve centers for spreading vital news and sanctuaries for outlawed organizations," wrote Roxie Zwicker in *Haunted Pubs of New England*. "Certain pubs bore witness to ghastly deeds and sorrowful tragedies," Zwicker continued. "Some of them became tinged with the aura of the supernatural."

In Salem, taverns were the epicenter of the 1692 witch trials hysteria. Examinations of hundreds of innocents accused of witchcraft were held at local watering holes like Ingersoll's Ordinary in Danvers and Beadle's Tavern located at 65 Essex Street. Several of the accused who were eventually executed—including Ann Prudeator, Alice Parker and Reverend George Burroughs—had their pretrial hearings at the Salem tavern on Essex Street, and in the case of Burroughs, they were locked in a room for days before their inquest.

"The pretrial hearings of George Jacob Sr. and his granddaughter Margaret were held at Beadle's," explained the official guide to the Salem witch trials

Examinations of hundreds of innocents accused of witchcraft were held at local watering holes. Years after the witch trials hysteria, taverns became hotbeds of illicit activity, and some are believed to be inhabited by the long departed. *Courtesy of the Boston Public Library.*

tercentenary. "Margaret confessed under duress from the authorities and in doing so helped to convict her grandfather and George Burroughs, former minister of Salem Village. She later recanted her confession, but the men were hanged anyway. Margaret herself escaped probable execution only because she was too ill to stand trial."

The Ship Tavern and Inn, located at 214 Essex Street, which is the present-day location of the Salem Five Building, housed witch trials jurors and witnesses. In the 1770s, the tavern was renamed the Kings Arm Tavern, and during the Revolutionary War, it became the Sun Tavern.

There was also the spectral pig sighting outside a second tavern owned by the Beadle family, located near the present-day site of Cinema Salem and St. Peter's Church. "During Alice Parker's hearing, one John Westgate testified that a black hog had attacked and nearly devoured him one night just across the street from Thomas Beadle's tavern," the witch trials tercentenary guide confirmed. "Because his faithful dog fled from the beast instead of attacking it, Westgate deduced that the hog was actually Alice Parker or another specter she had sent to hurt him."

For the record, taverns became a hotbed of illicit activity years after the witch trials hysteria. The strip of businesses across from the House of the Seven Gables, including Witch's Brew Café and In a Pig's Eye Restaurant, serviced the sailors and captains visiting Salem's thriving seaport.

According to Christopher Dowgin's *Salem Secret Underground*, Derby Street was a red-light district replete with brothels and drunken sailors. "Captains had discreet tunnels into the brothels to meet up with the ladies and a good escape route during a raid," he wrote. "Also these tunnels provided means to shanghai sailors. As late as the 1950s, this was an area fathers would warn their daughters to avoid so they would not be mistaken for the ladies of the night."

Speaking of ladies of the night, several locations in Salem are allegedly haunted by the first woman executed in 1692. Her name? Bridget Bishop.

Bishop lived in Salem Village (present-day Danvers) but owned property on the eastern side of Salem's current Washington and Church Streets. As far as witchcraft, several men accused her of dabbling in the dark arts. John Cook Jr., an eighteen-year-old who lived on Essex Street, just opposite First Church, claimed he was awakened one morning by Bishop's specter, which was grinning at him. She "struck me on the side of the head, which did hurt me very much," he claimed. Bishop allegedly returned and caused an apple to fly from Cook's hand into his mother's lap.

Cook's neighbor, Samuel Shattuck, testified that Bishop's lacy garb was un-Christian, and when she visited the Stattuck home, their son began crying and became "stupefied and devoid of reason." Born Bridget Playfer, Bishop married Samuel Wasselbee and had two children. Her entire family, husband and children, died under mysterious circumstances. In 1664, Bishop married Thomas Oliver and had a daughter, Christian. Oliver also died, and Bishop remarried to Edward Bishop, hence her namesake.

Yes, the woman had a checkered past.

She was known as a penny pincher, and a local Salem woman claimed in 1682 that Bishop's specter, with Alice Parker, who was also accused and executed as a witch, pulled her down to the beach and tried to drown her. Of course, this was four years before the trials and a precursor to the accusations that would ultimately lead to her demise on June 10, 1692.

Historically, Bishop is credited with running a scandalous tavern near the present-day Lyceum. However, it's more likely that she's been confused over time with Sarah and Edward Bishop, who ran a watering hole out of their home down the street. They were sent to Boston's less-strict jail and managed to escape.

Bridget Bishop wasn't so lucky.

At her trial on March 24, 1692, several witnesses testified that a poltergeist attack took place as Bishop was being taken under guard past the town meetinghouse, a stone's throw from her Salem home and the present-day location of the Lyceum. "A demon invisibly entered the meeting house, tore down part of it, so tho' there was no person to be seen, yet the people, at the noise, running in, found a board which was strongly fastened with several nails, transported into another quarter of the house," wrote one eyewitness. In other words, spirits were supposedly active during the thirteen months of mass hysteria and were so powerful that a wooden board levitated across the room.

With that said, could actual paranormal activity be responsible for the paranoia that resulted in the onslaught of accusations in 1692? Yes, it's possible.

A&B SALEM

The former home of Salem's most wanted, which later became the city's most haunted, now serves up slammer-chic burgers and beer. Yep, the Witch City's new kid on the cellblock gives locals an up-close-and-personal view of one of Salem's more historic locales, the old Salem Jail next to the Howard Street Cemetery.

A&B Salem opened in the spot formerly occupied by the upscale restaurant known as the Great Escape. According to co-owner Amy Butler, she and her business partner found the perfect location—even if it is haunted. "It would have ended up being a missed opportunity with it being the old jail," Butler told *Ghosts of Salem*. "It was vacant for thirteen years and the restaurant that was here before only lasted three years. Salem didn't really get a chance to hang out here and get the idea of what really went on here."

The granite-walled jail and Federal-style keeper's house opened in 1813 next to the Howard Street Cemetery, where Giles Corey was crushed to death during the witch trials hysteria in 1692. The jail was expanded in 1885 when two octagonal cupolas were constructed. Magician Harry Houdini staged an escape in 1906, and Albert DeSalvo, commonly known as the Boston Strangler, was confined in the jail. In 1984, conditions were so inhumane inside—inmates still had to use chamber pots for bathrooms—a few detainees successfully sued the county for inadequate living conditions. A federal judge ordered the jail's closure seven years

A&B Salem, at 50 St. Peter Street, opened in the spot formerly occupied by the upscale restaurant the Great Escape. The new eatery offers an up-close-and-personal view of one of Salem's more historic locales, the old Salem Jail next to the Howard Street Cemetery. *Photo by Sam Baltrusis.*

later. Until then, it was considered the oldest active penitentiary in the United States.

Butler said the building's history was worth the initial hurdles of setting up a restaurant in the old jail's wing. "We had to go through a lot of extra steps that typical businesses didn't have to deal with," she said. "The building is government property. In terms of our signage, it had to fit the history of a building from 1813."

As far as the structure's ghost lore, Butler said she's heard a few cautionary tales. "When we were purchasing the building, the previous owners told us a few ghost stories," she said. "He said he would tell us a few but preferred not to tell us the others."

One encounter involved what looked like a figure wearing a dark shirt and pants, sporting an old-school cap and holding a clipboard. The previous owners initially witnessed this ghostly figure from a security camera. They thought he was a deliveryman until he disappeared in thin air. After reviewing the security-tape footage, the former owners were dumbfounded when only static appeared during the twelve minutes the figure made his appearance

According to sensitives who have visited A&B Salem, there is a lingering energy from the building's old jail days, including a male phantom believed to be a residual haunting of a prison guard holding a clipboard. *Photo by Sam Baltrusis.*

on screen. Now the owners have no recorded proof of the mysterious man with a clipboard. Patrons at the Great Escape claimed to have seen a similar man with period-dated clothing walking past the bar and disappearing.

"I have heard it was a janitorial gentleman with a set of keys and a period-dated hat," Butler said. However, it's believed that the figure is a residual haunting of a prison guard from the old jail's past. "When we were opening up this place, we definitely kept looking behind us," she continued. "There are spots in this building with freezing-cold air. I don't know what that means from a paranormal perspective, but it's cold in places where it shouldn't be cold. It's pitch black in the back. We try not to spend too much time there late at night."

For the record, these cold spots are signs of paranormal activity. In addition to the freezing patches of air, objects mysteriously break, and lights go on and off by themselves. "We have one employee who works in the back bar who constantly has the sensation that someone is breathing on her neck when no one is there," Butler said. "To be honest, the ghost stories kind of creep me out."

Then there is the ghost of Giles Corey, who supposedly unleashed his curse at the Howard Street Cemetery next to A&B Salem. "The rumor is if you see him, there is sudden death or heart-related death issues," she said. "I had a witch of Salem come up to the door and tell me if I see him, it's over."

Butler said she's wary of looking out at the Howard Street Cemetery. "They say Giles appears in the windows of my building," she continued. "I had two women come who said they had an 'out of body' experience at the previous restaurant. They were attached to the table, shaking like crazy. I guess they were mediums, and they said they could feel the spirits in the building."

According to psychics who have visited A&B Salem, there is a lingering energy from the building's old jail days. The disappearing man believed to be the residual haunting of the old prison guard hasn't been spotted recently. "We were worried that people who really like the old jail's aesthetic wouldn't come in," said Butler. "But they actually like our set up better. They enjoy hearing the stories from when this was the old Salem jail."

Butler's team removed the holding cell bars that were welded together and used as seating at the Great Escape. Oddly, the prison guard ghost hasn't been seen since the bars were removed. Perhaps, the spirit realized his call of duty was over and finally made his "great escape" when the old jail cells were moved.

File under: ghostly guard

BUNGHOLE LIQUORS

Spirits with Salem's spirits? During the Prohibition era, Bunghole Liquors on Derby Street had a past life as a funeral home. However, what was happening downstairs was enough to the raise the dead. Locals would gather next to the parlor's embalming equipment, down some illegal booze and hangout in a spot that housed the city's recently deceased.

"Liquor flowed freely in the funeral parlor basement, the same place where the bodies were embalmed," confirmed the Bunghole's website. "One of the owner's drinking buddies is rumored to have told him, 'If Prohibition is ever lifted, you should turn this place into a liquor store.' So in 1933, he did just that. One of the original owner's relatives (interestingly, a Polish priest who was being ordained) suggested The Bunghole as an official name."

The liquor store's quirky moniker was a slang term used by the locals to refer to the group's secret drinking spot. For the record, a "bunghole" is the hole in a cask or barrel. It's a fitting nickname since the liquor store is literally across the street from the city's once-thriving Derby Wharf.

Apparently, the original owner would smuggle in the illegal spirits using an underground tunnel connecting the structure to the wharf. Most of the booze was hidden in barrels.

"They had the second liquor license to be issued in the city after Prohibition," wrote Christopher Dowgin in *Salem Secret Underground*. "So the corpses moved out, the embalming tubes were buried in the walls and the tunnels were closed."

According to the Bunghole's website, the ghosts from its funeral parlor past still linger in the basement: "If you crept downstairs and tore down a few walls today, you'd notice the embalming tubes (and no doubt a few empty flasks), left behind from the ancestors of The Bunghole, who occasionally haunt their old, secret hangout."

Brandon O'Shea, the assistant manager at Bunghole Liquors, confirmed the rumors with *Ghosts of Salem*. "This place is definitely haunted," he said. "I came here, and I heard it was haunted, but I never believed it."

O'Shea said a few recent encounters with the paranormal at the liquor store has challenged his lifelong skepticism. "The light was off, and I was in the bathroom," he recalled. "I swear to God a cat rubbed up against me. I'm not a believer in that sort of thing, but I ran out and asked [a coworker] if there was a cat or dog in the building. He said, 'No.' There was nothing there. All I know is that something touched my leg."

The Bunghole, at 204 Derby Street, is a former Prohibition-era funeral parlor turned liquor store. According to recent reports, the spirited haunt is home to a phantom cat and possibly a female energy known to hide behind the wine racks. *Photo by Sam Baltrusis.*

In addition to the ghost cat, the former skeptic said a full-bodied apparition of a woman mysteriously walked throughout the shop last New Year's Eve. "We just had a big rush," O'Shea recalled. "My coworker saw this woman walk behind the wine rack and go out back. It's two hours later, and my other coworker bumped into a woman, but there was no one there."

O'Shea said he stays away from the basement area that formerly housed Bunghole Liquor's illegal, speakeasy drinking spot. "One of the cameras downstairs picked up white lights downstairs," he said. "When you're working alone, you always see weird things here. I'm telling you, I'm the last person ever to believe in this stuff. But something is here."

So what rubbed up against O'Shea's leg? According to Susanne Saville's *Hidden History of Salem,* a gaggle of ghost cats prowls the city at night. "For the Halloween capital of the world, Salem's ghost population is surprisingly small. And furry," she mused, alluding to the feline spirit allegedly haunting the Stephen Daniels Inn. There's also an odd incident at the Witch House

from 1897 involving photographer Walter Sprange. "In the view presented one of the most woe-begotten, ill-shaped cats," Sprange wrote, saying a feline spirit was peering out of the open casement. "In another view taken it appears in the doorway." Apparently, Sprange captured a spectral kitty peeking out of the rear of the Witch House in the late 1800s. However, he only mentioned them in his notes and never published the photos.

Both Nathaniel Hawthorne and witch trials victim Giles Corey loved the four-legged felines. In the early nineteenth century, a legendary cat called Pompey lived in Salem. She crossed the Atlantic in the Americas' first yacht, *Cleopatra's Barge*, owned by wealthy Salemite Benjamin Crowninshield. "We found a yellow cat lying on the bed," reported one of the barge's visitors. "The captain said she came on board on her own accord, and had chosen her position. He intended to take her with him for good luck." Pompey passed in 1817. However, it's possible that her spirit is wandering the streets of Salem and somehow made a pit stop at the Bunghole. Yes, it seems that cats do indeed have nine lives.

File under: phantom feline

CINEMA SALEM

Popcorn and poltergeists? The city's only independent movie theater, Cinema Salem, is the last house standing in a neighborhood that formerly boasted seven entertainment venues.

Names like the Federal Theatre, the Empire and the Comique thrived during the city's Vaudeville era. The Plaza Theater, formerly located at 273 Essex Street, was built in 1913 and burned down four years later. Almost all of Salem's entertainment complexes closed during the Depression, but others, like the Paramount built during the 1930s, survived until 1971. It was torn down to make way for the East India Mall.

The current Cinema Salem in the indoor complex has had a past life since the '70s, ranging from a USA Cinema to a Loews in the '80s to the Salem Flick. The three-screen theater reopened in 2006 as an art-house gem known as Cinema Salem.

According to assistant manager Peter Horne, the ghosts from its silver screen past still linger. "Multiple co-workers have had experiences here in the theater," he said. "In the past, we've had psychics, ghost hunters and paranormal investigators inside."

Horne said a former manager spotted what looked like a man in black sitting in theater No. 3 when he was upstairs in the projection booth. "He looked down and saw someone sitting in the theater," Horne recalled. "There was no movie playing, so he freaked out and ran down to kick them out. The man disappeared. According to him, he looked like a middle-aged man, wearing coattails. His clothing was from the Victorian era."

After giving a tour of the theater, Horne walked me up to the cramped projection area. "It's very uncomfortable in here at times," he said. "I'm not sure if it's because it's surrounded with concrete and it's just cold and dark, or if there is something else going on. Anybody who has been up in the projection booth says it's creepy and uncomfortable to be up here."

There are other reports of the mystery man's reflection in the projection booth's window. Also, smoke mysteriously emerged from the corner spot in theater No. 3, believed to be the favorite seat of the ghostly man wearing Victorian-era garb. Perhaps he smoked a pipe?

One former manager said she felt an unseen force push her while leaving the projection booth. "She said multiple times that she felt a force pushing

Cinema Salem, located in India Square Mall, is home to a Victorian-era male spirit with coattails. According to employees and patrons, he's known to frequent the corner seat in theater No. 3. *Photo by Sam Baltrusis.*

her down the stairs, almost kicking her out," Horne claimed. "A team of ghost hunters came in to investigate. They did their thing and said that they picked up on a guy dressed in black, with coattails and who sits there watching movies. He doesn't like it when people are in the theater and leaves when it's crowded."

Horne was surprised that the story he heard from his former manager oddly matched the description of the middle-aged man wearing black from the paranormal investigation team. In addition to the sightings of the gentleman's full-bodied apparition, alleged poltergeist activity has been reported involving keys and lights mysteriously turning on and off. One employee claimed that his key chain was unclipped from his belt, levitated before his eyes and then disappeared. They found the keys hours later in a room that was securely locked.

"When the investigators were here, they said one spot in theater No. 3 appears to be some sort of portal," he said. "The former assistant manager brought her niece here. She stumbled in the theater and got scared at the exact spot where the old man has been seen."

So why haunted theaters? Holly Nadler, author of *Ghosts of Boston Town*, believes it's the romantic aesthetic. "All old and beautiful theaters look haunted, with their shadowy corridors, flickering lanterns, vaulted ceilings and Gothic ornaments," she wrote. "They also sound haunted, from the creaking of the woodwork, the rustling of old pipes, the sighs of air currents trapped inside thick stone walls. And indeed, there are some who contend that all old and beautiful theaters really are haunted."

In addition to its ghost lore, the land occupied by the cinema in Museum Place Mall has some seventeenth-century history. It was known as Samuel Beadle's tavern in 1692. Yep, it's the spot where John Westgate claimed he was attacked by a spectral hog sent by witch trials victim Alice Parker.

Cinema Salem isn't New England's oldest theater. However, it's arguably the North Shore's most active. It's believed that the movie-loving specter in black relocated from the Paramount down the street and has made a postmortem return to reclaim the corner seat in theater No. 3. Yes, all the world's a stage…and all of the lingering spirits are merely players.

File under: creep show

LYCEUM HALL

Turner's Seafood, located in Salem's historic Lyceum Hall, is believed to be the site of Bridget Bishop's apple orchard. It's also the spot where locals believe the innocent woman's residual energy still lingers. For the record, she was the first of twenty to be executed in Salem in 1692, and she was the only one to be hanged separately at Gallows Hill.

Years later, the historic lecture hall was built on Bishop's land. Nathaniel Hawthorne was appointed the corresponding secretary of the Salem Lyceum in 1848. Guests who came to speak that season included Emerson, Thoreau and Louis Agassiz. Apparently, the successful author had a tinge of stage fright and refused to actually go to the podium to speak. In addition to Hawthorne's literary friends, Alexander Graham Bell gave a spirited lecture at the 43 Church Street location. In fact, the historic building is where Bell first revealed his plans for the telephone.

The site hosted Vaudeville-type performances in the late 1800s, and after a fire in 1894, the original wooden structure burned down. It was rebuilt as a two-story brick building and reopened as the Colonial Café in 1935.

Stories of ghostly apparitions have emerged from the old Lyceum building since it opened as a restaurant in 1973. It's had different names over the years, including Lyceum Bar & Grill, which opened in 1989, and 43 Church. Numerous people have reported seeing a woman in a long white gown floating above the Lyceum building's main staircase. Her image has been seen in the windows and mirrors throughout the building.

Terri Colbert, a former employee at 43 Church, shared on the History Channel 2's documentary that she came face to face with the full-bodied apparition of a woman while walking up the stairs. "It was a busy night," she recalled. "When I came up the stairs and looked up, I saw another woman standing on the other staircase leading up to the loft. I was petrified. My initial thought was that it was a person breaking into the restaurant. When I realized she wasn't a regular person, I ran back downstairs and almost fainted."

Colbert said the ghostly woman "was dressed in white and wearing seventeenth-century garb. When I realized it was an apparition, I was scared."

In a recent episode of the Travel Channel's *Ghost Adventures*, the crew members picked up what they thought was proof that they were interacting with the ghost of a woman put to death on charges of witchcraft. Also, the team from *Ghost Hunters* examined the mirror that may be the cause of some of the sightings. However, when the TAPS team attempted to

Turner's Seafood, located in Salem's historic Lyceum Hall at 43 Church Street, is believed to be the site of Bridget Bishop's apple orchard. Stories of ghostly apparitions of the first person executed during the witch trials hysteria have been legendary since it first opened as a restaurant in the '70s. *Photo by Sam Baltrusis.*

contact the spirits, an old-school cash register came to life. One of the credit card machines printed out a receipt with a time stamp and the words "good morning." Oddly, the credit card machines weren't set up to print out "good morning."

Tim Maguire from the Salem Night Tour believes Bishop's spirit lingers in the historic building. "It's very common to hear things like voices or footsteps when nobody is around," Maguire said on the History Channel 2's documentary. "Many people watch a woman walk by who suddenly disappears. We've had dozens of photos of faces in the window looking out and hands up against the glass. People feel sadness. Bishop, when she was brought to trial, wasn't treated very well. Spirits left behind would hang around and convey sadness if they were wrongly accused."

In other words, the tragic last days of Bishop's life may have psychically left an imprint on the environment.

Colbert, who witnessed poltergeist activity in the building like chairs being moved, said she believes Bishop's ghost is determined to set the record straight. "She wouldn't like the idea that people thought she was a witch," she said. "I still think Bridget Bishop is still around here professing her innocence."

Oddly, many people have reported fainting or feeling uneasy in the area behind the Lyceum. Paranormal investigators have picked up a high level of electromagnetic activity in the courtyard space behind the building. It's possible that this inexplicably high level of energy is related to the recurring reports of paranormal activity. Some claim they've smelled apple blossoms, and others have seen the forbidden fruit strategically placed around the historic structure. For the record, there are no apple trees near the Lyceum.

One group practicing Wicca in the city conducted a circle at a private Halloween party on the second floor of the Lyceum Bar & Grill. According to lore, they were trying to communicate with the spirit of Hecate, the Greek goddess of magic and necromancy, as well as Bishop. Instead, they summoned the spirit of a young girl whom they call Annabelle. In fact, there's an infamous picture of the ghost girl, who reportedly has long, wavy hair and looks similar to the antagonist from the movie *The Ring*, at Crow Haven Corner on Essex Street. Some say the teen spirit still inhabits the buildings in Salem and has been seen in reflections of the various storefronts in the downtown area.

File under: cry innocent

ROCKAFELLAS

Truthfully, you can't walk a block in the "Witch City" without passing a building with a haunted reputation. However, the ghosts supposedly inhabiting Rockafellas on the corner of Washington and Essex Streets are among the city's more notorious thanks to the lore associated with the legendary "Blue Lady." In fact, the restaurant named a specialty cocktail after her, called the Lady in the Blue Dress, made with rum and blue curaçao. According to the menu, "after this one, you may see her."

Who is this "Blue Lady" spirit? "She's supposedly the specter of an employee who died where Rockafellas now stands, back when the site was Daniel Low & Co., a pioneering department store," wrote *Zagat* reporter Scott Kearnan. "The building also functioned as a church, which may explain sightings of a black-suited minister, and had plenty other uses that add to its creepy character."

According to lore, the ghostly minister committed suicide when the building was a meetinghouse. He's been spotted in the downstairs area and is said to be a recluse. One report claimed the spirit said, "Git, I don't want to talk to you right now" when confronted.

The building's history is almost as interesting as the ghosts that allegedly linger there. Carved into the stone of a commemorative marker outside is the date 1826, which refers to Salem's First Church. The church used the building's second floor for worship and rented out the ground floor for various commercial establishments. Its past included a clothing shop for ladies and a dry goods store. Daniel Low moved into the structure in 1874, and his jewelry and gift business flourished. Low's bestseller? He created the souvenir witch spoon in the late 1800s, which launched Low's national mail-order business.

Low died from a heart-related illness in 1911. His son, Seth, continued the family legacy until 1939, when his widow took over. The historic building was eventually sold to William Follett in the 1950s. Rockafellas opened in 2003.

It's a little-known fact that the Daniel Low structure had a short stint as a live theater in 1828. "The building was actually erected four years earlier by a group of investors who wanted to bring live theater to Salem," reported the *Salem Evening News*. Its first production was called "Wives as They Were and Maids as They Were." Apparently, Salem couldn't support the expenses associated with live performances. "Despite the excellent quality of this and subsequent productions, and the appearance of

Rockafellas, located in the historic Daniel Low & Co. building, has reports of a "Blue Lady" spirit and a ghostly minister who supposedly committed suicide when the building was a meetinghouse. *Photo by Sam Baltrusis.*

nationally known actors Edwin Forrest and Mary Duff, the Salem Theatre only lasted a few years."

The "Blue Lady" ghost made her debut appearance when Rockafellas opened in 2003. An employee shot a nighttime photo and posted it on the restaurant's website. In the picture is the full-bodied apparition of a lady who mysteriously appeared in front of the building. Rockafellas embraced its resident spirit and handed out T-shirts to patrons who claimed to have had a spirited encounter at the restaurant. The T-shirts read "Congratulations! You've Just Seen the Lady in the Blue Dress."

The lighthearted ghost lore turned dark when visitors, mainly women, claimed they spotted the lady in the downstairs hallway. Then there were the screams. Several employees heard mysterious, disembodied cries—as if someone was buried alive—coming from the building's downstairs vault area. "Underground tunnels (now filled with concrete) once connected the site to other buildings around downtown Salem, and some of them were used as part of the Underground Railroad—leading to rumors that some slaves unsuccessfully seeking freedom were buried there," continued Kearnan. "The building was also a historic bank, and for the ultimate eerie factor you can reserve the single table for two that sits in the former vault."

Ghost tours have elaborated over time with lore associated with the "Blue Lady" legend, suggesting that she was possibly murdered in the underground tunnels beneath the Daniel Low building. One story claimed she was expecting and waiting for the sailor who impregnated her at the Salem First Church. She demanded that the man marry her. According to unsubstantiated lore, the sailor murdered the woman and buried her in the tunnels beneath the building. It's supposedly her eerie screams that echo in the lower-level vault area beneath Rockafellas.

True? Probably not. However, there's convincing evidence of desecrated human remains beneath the building. According to *Salem Secret Underground*, the building's underground system connected an underground warehouse near the current Goddess Treasure Chest located in Derby Square. It's also where two runaway slaves are believed to be entombed. "The story goes that somewhere in Salem two gentlemen died and were not allowed a proper burial because their existence might hinder others who longed for freedom," wrote Christopher Dowgin. "So they encased them in a concrete tomb."

Yes, the underground network did exist. However, when William Follett bought the building in the 1950s, he had the underground tunnels filled in with concrete.

In honor of the mysterious cries from below, Rockafellas created a specialty drink called the Screaming Vault made with dark rums and juice. According to the menu, patrons can even keep the glass. Why? One of the many bizarre occurrences at the restaurant involves glass mysteriously breaking. Several visitors have watched in awe as their stemware shattered before their eyes. In another freaky encounter, a bartender claimed that a glass levitated from the bar's rack, bounced into the air and landed on the counter without breaking. Now, that's a thirsty spirit.

File under: screaming vault

Chapter 6
OVERNIGHT HAUNTS

Hotels where guests check in but don't check out? In Stephen King's *The Shining*, chef Dick Hallorann explained to the young Danny Torrance why the ghosts from the fictional Overlook Hotel continued to linger. "I don't know why, but it seems that all the bad things that ever happened here, there's little pieces of those things still laying around like fingernail clippings," he warned. Past traumatic events like murders and suicides can leave a supernatural imprint on a building, according to the telepathic chef.

When it comes to hotels replete with paranormal residue, Salem isn't immune. "The Hawthorne Hotel is built on a property that once held a building that burned down six times taking many lives," wrote Christopher Dowgin on *Salem Secret Underground*'s blog. "In its parking lot once stood the Crowninshield-Bentley House, which was featured in H.P. Lovecraft's *Thing on the Doorstep*. Its other parking lot is holy ground for a Jewish Temple that once stood there."

As far as hauntings, the Hawthorne Hotel allegedly boasts phantom hands in room 325 and a female, full-bodied apparition on the sixth floor. However, when Syfy's *Ghost Hunters* investigated reports in 2007 of strange sounds like children crying and unseen forces touching guests in the hotel, it didn't uncover anything supernatural. Yet enthusiasts continue to claim a female apparition hovers in front of room 612.

Of course, the Hawthorne Hotel isn't the only overnight lodging in Salem with reported supernatural activity. The Morning Glory Bed and Breakfast, literally across the street from the House of the Seven Gables, has alleged

activity in each of the four rooms named after witch trials victims: Elizabeth Howe, Rebecca Nurse, Sarah Good and Bridget Bishop. Psychic mediums who have stayed in the third-floor Sarah Good suite claimed they spotted ghost children jumping up and down on their bed. Supposedly, there are unsubstantiated reports that several kids have died in the house, which was built in the early 1800s.

Oddly, psychic Denise Fix, featured in *Ghosts of Cambridge*, talked about a similar experience with kid spirits in her childhood home facing Salem's wharf area. "I was five or six when it first started," she recalled. "I couldn't go to sleep at night, and my mother wanted to know why, and I told her about the kids in my room. She thought it was a nightmare, but I knew it was something else."

Fix said her childhood was like a scene from Stephen King's *It* or *The Shining*. "These kids would appear, and they wanted me to go to a party," she explained. "In my head, I knew if I went to a party with them, I wasn't coming back. And then the ghost kids were like, 'If you don't go to the party, we'll get your sister to go. So, I jumped on my sister to protect her, and she woke up screaming, saying I attacked her. My family thought I was nuts."

In addition to the playful ghost children, the Morning Glory located at 22 Hardy Street hosts a teenage girl spirit with long, wavy hair in the Bridget Bishop room. One former guest claimed on the inn's website that the full-bodied apparition of a young woman, between seventeen and twenty years old, manifested in front of her and smiled. "She was dressed in a long gown from the late 1800s, early 1900s," she wrote. "It was white, trimmed in royal or dark blue. She had very light brown or dark blonde hair, pulled back off her face but it cascaded over her shoulders."

Salem's most active? The Hawthorne Hotel continues to make national "haunted hotel" lists even though the team from *Ghost Hunters* didn't capture paranormal activity during its made-for-TV investigation.

Elliott O'Donnell, an Irish author who became an authority on the supernatural during the early 1900s, wrote about a close encounter at a no-name hotel in the area with "an undeniable reputation for being haunted" in his book published in 1917 called *Experiences as a Ghost Hunter.* "I only stayed in town two nights," he wrote, not citing a specific location. "It was in a rather poor neighborhood and there were few visitors." O'Donnell, who had an uncanny ability to embroider fact with a grandiose flair for fiction, allegedly chatted with the night porter about the hotel's elevator, which had a mind of its own. "A visitor arrived here late one night and was found by the day porter dead in the lift," the porter recalled. "How he died was never

The Morning Glory Bed and Breakfast, at 22 Hardy Street, has alleged activity including rambunctious ghost children who notoriously jump on beds and a female teen spirit with long, wavy hair. *Photo by Sam Baltrusis.*

exactly known. It was rumored he had either committed suicide or been murdered...Since then that elevator has taken into its head to set itself in motion at the same time every night."

Haunted elevators? Yep, it's a recurring theme at a certain Salem hotel where visitors stay a few decades or so beyond checkout time.

HAWTHORNE HOTEL

History and mystery ooze from the lobby of the Hawthorne Hotel, which opened its gilded doors on July 23, 1925, amid much fanfare and excitement. Approximately 1,110 area residents and businessmen bought stock in what would become the city's grand dame: a six-story, 150-room hotel on a piece of land formerly occupied by the fire-prone Franklin Building.

Yes, the Hawthorne Hotel's site had a history of bad luck, which included a series of destructive fires. "An easterly gale was raging, and the fire progressed, in spite of all of the efforts to save it, until the noble structure, which has been one of our institutions for about sixty years, and which extended from Essex to Forrester street, was a complete mess of ruins," reported the *Salem Register* in the 1800s.

Of course, the building named after Salem's native son Nathaniel Hawthorne has been plagued by less-destructive blazes over the years. In October 1997, a small fire broke out in the hotel's basement and caused an estimated $10,000 in damage. "Smoke reached all six floors of the hotel and the Hawthorne's main ballroom suffered considerable smoke damage," reported the *Salem Evening News*. Luckily, no one was hurt.

It's possible that the psychic imprint from the cursed land's past may have caused what parapsychologists call an aura of disaster—fertile ground for the birthing of ghosts. According to several accounts over the years, the Hawthorne Hotel does indeed have a storied history of alleged paranormal activity.

"Surrounded by the many grand homes erected by the wealthy sea captains, the Salem Marine Society was founded by the skippers in 1766," wrote Lynda Lee Macken in *Haunted Salem & Beyond*. "The society's building was razed when the town determined it was time to construct the hotel. As a condition of acquiring the land, the hotel's owners agreed to provide a meeting place for the men. Some employees wonder if the spirits of some of those old sea captains have returned."

Officially opening in 1925, the Hawthorne Hotel is a six-story, 150-room hotel on a piece of land formerly occupied by the fire-prone Franklin Building. *Photo by Sam Baltrusis.*

The Salem Marine Society's secret meeting spot is on the off-limits roof of the Hawthorne Hotel and is an exact replica of a cabin from the *Taria Topan*, one of the last Salem vessels to sail regularly during its golden maritime trips to East India. Several employees and visitors claim that the large ship wheel now in the restaurant mysteriously spins, as if unseen hands are steering it, when no one is there.

Other encounters include water faucets turning on and off and toilets flushing on their own. There are many reports of disembodied voices echoing throughout the hotel and so-called phantom hands in the structure's allegedly most-active rooms, 325 and 612.

When the TV show *Bewitched* shot several episodes in Salem, the cast and crew used the allegedly haunted Hawthorne Hotel as their home base. In fact, Elizabeth Montgomery's stay in Salem is immortalized in a Samantha Stephens statue in Lappin Park. For those out of the pop-culture loop, Montgomery rode into town to film eight episodes of *Bewitched* during the summer of 1970. "For years after the two episodes aired as the *Salem Saga*, the hotel desk fielded telephone calls asking if this was the Hawthorne Hotel that was seen on *Bewitched*," reported the hotel's newsletter. In the show, the building was known as the Hawthorne Motor Hotel.

The elevator made famous during its *Bewitched* days apparently has a mind of its own. It's believed to be haunted by an invisible presence, and some say a ghostly woman has taken a ride with them in the elevator. The same female residual haunting has been spotted in rooms and mysteriously disappears when guests confront her.

The Hawthorne Hotel's reputation as Salem's "most haunted" sometimes surpasses its historical significance. In 2007, it made the fourth slot on Travelocity's haunted hotel list, which surveyed overnight haunts across the country.

However, the hotel's general manager said the claims of paranormal activity simply weren't true. In fact, she cited an episode of *Ghost Hunters* shot at the hotel as proof. "There's no documentation," said Juli Lederhaus in the October 24, 2011 report in the *Boston Globe*. "People tell us they feel things, whatever, but we don't have any documentation. Of course, [guests] do look up haunted hotels on the Internet and those things pop up. The more people cite those kinds of stories the more they get published out there. I feel like I'm constantly putting out fires."

Oddly, fire may be the "psychic residue" visitors claim to sense when visiting the hotel. Lederhaus reiterated that the myth, perpetuated in several books, that the hotel marks the former site of the apple orchard owned by Bridget Bishop isn't true. As discussed in the Nightlife Haunts chapter, Bishop's property was near the current spot of the old Lyceum Hall. Investigators with *Ghost Hunters* told the general manager they went to the library, City Hall and did research on the physical property and claimed "nothing happened at the hotel that would cause hauntings."

Seriously? The TV researchers completely overlooked the six fires

In 2007, the Hawthorne Hotel made the fourth slot on Travelocity's haunted hotel list, which surveyed overnight haunts across the country. Citing an investigation by Syfy's *Ghost Hunters*, the hotel's general manager said the claims of paranormal activity simply weren't true. *Photo by Sam Baltrusis.*

that plagued the land's previous occupant, the Franklin Building, during the 1800s. "A few years since, a brick partition wall was erected, and this saved the entire building from destruction, and prevented the conflagration from spreading to an untold extent among the wooden structures in the vicinity," reported the *Daily Advertiser* on February 1, 1845.

John Marsicano, a regular visitor to the hotel, said the *Ghost Hunters* investigation shouldn't rule out the possibility of paranormal activity. "I think those guys are good and do their endeavor earnestly and are honest about it," he told the *Globe*. "But ghosts and spirits, if they do anything, might not do it on command."

Of course, Lederhaus did point out that two other buildings existed at the site before the hotel. "Could something have happened in one of those buildings?" she said. "Who knows?"

File under: haunted Hawthorne

SALEM INN

An inexplicable supernatural energy emanates from the high-ceilinged Victorian rooms in the Salem Inn. Besides being one of the more cozy accommodations in Salem, it's also allegedly one of its most haunted. Reports of disembodied voices, doors mysteriously opening and closing, shadow figures and phantom footsteps have been chronicled in a diary kept in the lobby's sitting room. Guests can enjoy a complementary glass of sherry and a creepy ghost story or two at this historic hotspot.

Comprised of three homes, the Captain West House is by far its largest and arguably most active. The Federal-style mansion's namesake, Captain Nathaniel West, was married to Elizabeth Derby. The couple seemed to have it all, including money and prestige. But apparently not marital bliss. They divorced in the early 1800s after a highly publicized legal brawl. At the trial, dozens of prostitutes were gathered from the area to testify against West. Ex-wife Derby passed in 1814, and West remarried in the mid-1830s. The wealthy sea captain's brick mansion was built in 1834 on the land formerly owned by witch trials judge Jonathan Corwin.

As far as hauntings, West is believed to haunt the upper floors. The full-bodied apparition of a middle-aged woman has been spotted in the building's creepy basement breakfast room. Apparently, she likes to peek out into the courtyard from a window.

Reports of disembodied voices, doors mysteriously opening and closing, shadow figures and phantom footsteps have been chronicled in a diary kept in the Salem Inn's sitting room. Room 17 is believed to be inhabited by the Salem Inn's house spirit Catherine. *Photo by Sam Baltrusis.*

There are also reports of a child spirit. "The staff has tales of a prankster child ghost that runs up and down the staircase and along the upstairs hallways. Doors will open and slam. Small pebbles will be tossed at the clerks working the lobby desk. Guests report items in their rooms being moved about and discovered in a new location," reported Haunted Places Examiner website.

However, Room 17 seems to be the most active. Based on reports kept in the diary, guests have experienced a "filmy white apparition" of a woman sitting on their bed in the Jacuzzi room. People in the same house have been kept awake by loud pounding and banging noises on the walls and ceilings throughout the night. There have also been reports of phantom gunshots heard in Room 17.

"My husband was in the shower and I was in bed with my eyes closed," reported one woman in the diary. "I felt someone sit on the edge of the bed beside me. Thinking it was my husband, I opened my eyes to say

something—but he was still in the bathroom. It felt more like a child's weight than an adult weight."

Another guest reported seeing a "dark figure in a long coat and rain hat." She asked him who he was, and the spirit of Room 17 responded cryptically: "Don't touch me, the dullness rubs off."

It's believed that the female apparition in the room is called Catherine. "She is often recognized as a sudden cool breeze that whisks past visitors on the stairs or hallways," continued the Haunted Places Examiner. "Or perhaps she is the disembodied voice one hears on a quiet night chatting to a gentleman about their child. She has been sighted in and around Room 17. Ghost hunters have recorded voices when using a ghost box."

Other guests report the phenomenon known as sleep paralysis—the feeling of "being pinned down and frozen in bed"—in Room 13. And others claim to see their doorknob turn, as if someone is trying to come into their room, when no one is there. One family was creeped out by inexplicable noises: "We are hearing noises all over the place—footsteps, a baby crying, a scratching noise. There are bangs coming from the basement. So many things."

Disembodied voices and shadow figures are common in Room 40. "I woke up about dawn and saw a figure standing on the balcony," reported one guest. "I sat up quickly and said, 'Who are you?' The figure was suddenly gone."

Of course, the owner of the Salem Inn believes the ghost lore is nonsense. "Please note that we have many guests who write about their visitations and experiences with the supernatural or hauntings or whatever," wrote Diane Pabich. "Neither we, the owners, nor any of the staff have had such occurrences. I personally think it is the power of suggestion and the fact that these guests are visiting Salem with its fascinating history."

However, employees swear the common sensation of a cold breeze whooshing by them in the lobby is the Salem Inn's house spirit Catherine.

File under: spirited inn

STEPHEN DANIELS HOUSE

Looking for a room with a "boo," or would a "meow" suffice? Patrons at the historic Stephen Daniels House swear a phantom feline roams the inn and creeps in and out of rooms. Catherine "Kay" Gill purchased the property in

the early '60s and has been the Stephen Daniels House owner and innkeeper for over fifty years. Apparently, she doesn't suffer from cat-ghost fever.

"In 1953, ten years before she bought the inn, she painted a portrait of a gray tabby," wrote Cheri Revai in *Haunted Massachusetts*. "When she moved in, she hung the portrait in the Rose Room—the same room guests tell her is haunted by a gray-and-black striped cat that looks just like the one in the painting."

The oldest bed-and-breakfast in Salem was built in 1667 by Captain Stephen Daniels and served as the private residence for his descendants for over three decades. Daniels's great grandson, Samuel Silsbee, extended the house in 1756. Before becoming an overnight haunt, it was converted into a private, two-family residence for a few years. It remained vacant until 1945 when the Haller family transformed the structure into a restaurant and inn. Gill purchased the historic building in 1963.

"Kay herself has never heard so much as a purr," continued Revai. "But her patrons assure her that she does, indeed, have a ghost or two, and that's OK with them."

Built in 1667 by Captain Stephen Daniels, the oldest bed-and-breakfast in Salem is rumored to be haunted by a gray-and-black striped cat and its original owner. *Photo by Sam Baltrusis.*

One of the more popular spirits spotted at the Stephen Daniels House is of a full-bodied apparition of a man who bears a striking resemblance to a man featured in a painting hanging in the dining room of the classic colonial structure. Gill told Revai that "a guest sleeping in the great room had a visit from a man in a shiny black suit and top hat who, from the description, looked remarkably like Stephen Daniels." According to Gill's description, the male apparition appeared to be an intelligent haunting and is known to say "welcome to the house" to overnight visitors.

Based on previous interviews with paranormal experts, it's common for a building's original owner to stick around a few centuries after their death.

"Spirits are attracted to the places they lived in," opined the late Jim McCabe, who was a noted ghost lore expert in Boston. "I think what attracts ghosts up here is that you don't tear down the buildings."

Adam Berry from *Ghost Hunters* echoed McCabe's belief. "My theory is that when one person works so hard to build an empire, whether it's a city, a business or an estate, they can still be around trying to check on what's going on and how those who are still there are running the place," Berry said. "I absolutely believe that New England has tons of spirits because it was the center of everything. People were building empires, and the more energy that surrounds that kind of situation, the more likely there will be spirits lingering about."

Of course, it could merely be the Stephen Daniels House's sentinel spirit. "The motif of the haunted house is a deep-rooted one, perhaps having its origin in the ancient belief that each place, including dwellings, had its own 'genuis loci,' which in Roman mythology meant the protective deity/spirit of a location, but which could be the place's distinctive spirit," wrote Brian Haughton in *Lore of the Ghost*.

The third spirit is an alleged residual haunting of a woman who replays her tragic fall down the stairs. "At least one guest to the inn has seen the woman descend one of the staircases inside the house," wrote Mark Jasper in *Haunted Inns of New England*. "It should be noted that the ghost appears none too nimble or perhaps there have been renovations since the first time she set foot in the Daniels house…for the ghost has been known to fall down the stairs as she attempts to descend them."

Of course, the ghost cat appears to be the most common apparition spotted in the colonial-era building. For the record, phantom felines are commonplace in Salem. "No one knows where the cat comes in, although for a house in Salem to exist without a cat would have to be some sort of minor miracle," mused Susanne Seville in *Hidden History of Salem*. "In

any case, guests have repeatedly commented on the tabby, only to be told the inn has no cats."

Revai joked that the return visitors to the inn say the cat ghost is part of the Stephen Daniels House's charm. "Return customers even remember to leave a bowl of milk out at night, hopeful that they'll once again encounter their furry friend."

File under: hello kitty

Chapter 7

WITCH HAUNTS

Salem doesn't want to be the next Spooky World. At least, that's what local haunter John Denley, known in the haunted-house business as Professor Nightmare, was told when he set up shop in the city a few decades ago. Over the years, he's had his hand in a lot of the city's scare tactics, including Terror on the Wharf and the current Witch Mansion on Essex Street. His consulting business, Boneyard Productions, helps clients around the world create spooky spaces, and he currently has an office on Derby Street. Denley, who helped build Witches Woods, Spooky World and Madison Scare Garden, said he's seen a backlash in Salem against the traditional haunter business.

"Salem would rather bury its history than embrace it," Denley said. "From my experience, Salem is indicative of the supernatural, but there's a push to focus on its maritime history. People don't come to Salem for its maritime history. They come here to be scared."

In response, Salem set up a bevy of "museums" to educate visitors, including the Witch Dungeon Museum and the Salem Witch Museum, while offering a few scares along the way. However, it wasn't enough. So, entrepreneurs like the Shea brothers set up the Haunted Witch Village, which later became the Haunted Neighborhood at the Salem Wax Museum.

"People were walking away from Salem disappointed that they did not get the scare," said Salem Wax Museum's Kathy Drew in *North Shore Sunday*. "Historically speaking, they were overly satisfied. But they weren't coming here just for the history. They want a haunt—to get frightened

Salem set up a bevy of "museums," including the Salem Witch Museum, to educate visitors about the city's witch trials past. Employees claim that books at the Salem Witch Museum's gift shop literally fly off the shelf. *Courtesy of the Boston Public Library.*

out of their wits. So we're going a different route. And there's nothing historical about it."

Of course, the Haunted Witch Village faced some controversy when it opened in October 1995. "I recently visited Salem because the witch trials were the only thing I remembered from high school history," said a New York visitor, adding that he was confused "that a town would make a tourist trade out of this horrible event. These are disasters, you don't celebrate them."

Jody Cabot, daughter of Salem's iconic witch Laurie, responded to the news. "It's analogous to opening up the gas chambers at Auschwitz, haunting it with Jews and making a fun ride out of it," Cabot said. "Over a

A backlash swept Salem in 2005 when TV Land decided to unveil a statue in Lappin Park of Elizabeth Montgomery's character Samantha Stephens from the '60s TV classic *Bewitched. Photo by Sam Baltrusis.*

three-hundred-year span, nine million people were killed under the wrong auspices of the word 'witch.'"

Cabot has a point. The debate, however, continued.

A similar backlash swept Salem in 2005 when TV Land decided to unveil a statue in Lappin Park of Elizabeth Montgomery's character Samantha Stephens from the '60s TV classic *Bewitched*. "It's like TV Land going to Auschwitz and proposing to erect a statue of Colonel Klink," said a former member of the Salem Historic District Commission. "Putting this statue in the park near the church where this all happened, it trivializes the execution of nineteen people."

The statue was erected despite the minor backlash and has become an icon of sorts for the "Witch City." Oddly, the statue's hand is pointing in the direction many believe is Salem's Gallows Hill, which is possibly located behind the Walgreen's at 59 Boston Street.

As far as paranormal activity, the real-life horror of 1692 possibly created what experts call an "aura of disaster," or an environment that triggers ghostly happenings. But what came first…did spirits exist in pre-Puritan Salem? The Naumkeag tribe, which was basically annihilated from a smallpox outbreak, believed the land was cursed with negative spirit energy. Spectral evidence, a form of testimony based on dreams and visions, was used by the so-called afflicted girls and up to fifty locals, which resulted in more than one hundred people put in jail and nearly two hundred innocents accused.

Perhaps poltergeists and other supernatural entities played a role in what became a cautionary tale of the dangers of religious extremism and the importance of due process.

OLD WITCH GAOL

The original dungeon in which the accused witches were held was constructed between 1683 and 1684. The jail was 70 by 280 feet and was made of hand-hewn oak timbers and siding. The conditions in the prison were notoriously horrific. Prisoners were held in small cells with no bedding. There were no bars on the cells, but if the prisoners ran away from their punishment, they were generally caught and immediately executed.

Prisoners were charged for straw bedding and food, and if they could not afford them, they did without. Water was also withheld from prisoners since the Puritans believed they would be able to get more "confessions" if the

Salem's Old Witch Gaol, located at 10 Federal Street, is the original dungeon in which the accused witches were held. It's also home to the angry spirit of a prison guard–type apparition known to make nightly rounds. *Photo by Sam Baltrusis.*

prisoners were thirsty. The salaries of the sheriff, magistrate and hangman were also paid by the prisoners, and they were billed for cuffs and other bonds and even for the torturous acts of searching their bodies for witchery "marks" and getting their heads shaved in the process.

At least five died from the inhumane conditions in the dungeon.

"In 1692, St. Peter's Street was known as Prison Lane and the jail was at the intersection with Federal Street, where a phone company building now stands," wrote Frances Hill in *Hunting for Witches*. "In the 1930s, a house stood on the site, built with timbers from the jail. In that decade, it became Salem's first Witch City attraction, when the Goodall family, who owned it, constructed a replica of the dungeons and charged admission. The Old Witch Jail and Dungeon, as it was known, drew thousands of visitors before it was bulldozed to make way for the telephone company building."

People say that the 10 Federal Street building is home to many spirits who have lost their lives over the years. Some claim it's haunted by the tortured victims of Salem's witch trials past. According to lore, workers in the building refuse to use the landline because there have been reports of torturous screams heard when they pick up the phone. As the legend goes, most in this building use their cellphones. Also, there have been reports of unseen forces touching people on the shoulder and ankles, and several workers reported feeling the sensation of being pushed out of the building.

There's also a prison guard–type apparition making his nightly rounds. His image has been caught on camera. Adam Page, investigator with F.I.N.D. Paranormal, said he has proof there's an angry sentinel spirit guarding the former Witch Gaol site. "The old guard at 10 Federal Street is really angry," said Page, a former case manager with Paranormal Salem. "We always run into his full-bodied apparition at that building."

Page said during his days working at Paranormal Salem, he would get a bad vibe from the Colonial-era sentinel. "The full-bodied apparition we caught at 10 Federal was walking straight down the hallway," Page explained. "He didn't see us, so I think he's more of a residual haunting. But he could be intelligent. If you look in the door, he walked right to left."

Speaking of Paranormal Salem, the team set up its office at nearby 30 Church Street, which oddly had a past life as a fire station for Salem's Engine 1. Yep, the team's home base is reminiscent of the movie *Ghostbusters*. The former fire station boasted a horse-driven Amoskeag Steamer armed with an old-school flywheel on one side only. Page said his investigation crew has captured quite a bit of activity there ranging from orbs to shadow figures. "There's a spirit of an old fire chief who shows up when we've done

investigations at the Church Street headquarters," Page said. "His name is either Jack or John, and he doesn't like men for some reason. However, he interacts with women, and he'll actually shake their hands."

Page said he believes the building has history associated with the Great Fire of 1914. "We had a pair of psychics come into the firehouse basement," Page continued. "The first thing they said is that they saw bodies. During the Fire of 1914, it was the only brick building in the area. We couldn't find any documentation to prove the building was used to hold bodies, but it would make sense historically."

Oddly, there's a photo in the Phillips Library Collection taken in the early 1900s outside of the former Church Street fire station. The mustachioed man, sitting at the helm of the old-school engine that was driven by three horses, has been identified in the book *The Great Fire of 1914*. His name? John Carter.

As far as the Old Witch Gaol, reports from the few who survived the prison without adequate food, heat or sanitary conditions compared it to hell on Earth. "Nearly everyone confined for more than a few days either attempted a prison break or wrote appealing letters to the court for mercy," wrote Edwin Powers in *Crime and Punishment in Early Massachusetts*. One gentleman, a servant known as Job Tookie, asked to be set free in 1682. "No one alive knows or is able to express what I have suffered since I came into this place," emoted Tookie, begging the court to take into consideration "this sad miserable and deplorable condition I am now in." Tookie's fourteen-week confinement was ten years before the witch trials hysteria. No one knows if he made it out alive.

File under: cruel punishment

WITCH DUNGEON MUSEUM

When the late author Robert Ellis Cahill helped build the Witch Dungeon Museum on Lynde Street with "glue, clay and some fifty mannequins," he had no idea its eerie reenactments from the 1692 witch trials hysteria would also become known for its haunted shenanigans.

Before the popular attraction opened, Cahill's nephew fell from a thirty-foot ladder, and other bizarre accidents hindered its initial launch until Halloween 1979. A rocking chair mysteriously moved on its own, but Cahill later identified the Witch Dungeon entity as a mischievous cat. Visitors also claimed to hear whispers and disembodied sounds. Actresses reenacting the

THE WITCH GAOL

HERE STOOD THE SALEM GAOL
BUILT IN 1684, USED UNTIL 1813
RAZED IN 1957

DURING THE WITCHCRAFT
PERSECUTION OF 1692, MANY
OF THE ACCUSED WERE
IMPRISONED HERE. ONE OF
THEM, THE AGED GILES
CORY (b.1611), WAS PRESSED
TO DEATH ON THESE GROUNDS.

The Witch Dungeon Museum, at 16 Lynde Street, boasts the original beam salvaged from the Salem Witch Gaol, a relic pulled from a lower dungeon hidden beneath 10 Federal Street. According to visitors, a mysterious ghost monk has been spotted in the building's dungeon area. *Photo by Sam Baltrusis.*

trial of Sarah Good refused to escort visitors into the dungeon because of sightings of a hooded monk ghost.

"He appears now more frequently near the crushing scene," wrote Cahill in *Haunted Happenings.* "I'm not one to so easily dispel their sightings anymore, for, after all, their ghost in the rocking chair proved to be real." The rocking chair incident had a rational explanation—it was a wayward puss in boots—but the numerous sightings of a full-bodied apparition continue to be a mystery.

Apparently, the ghost monk continues to make his rounds in the Witch Dungeon Museum's dungeon area. "If you see a shadow figure moving in the basement while walking through the old Salem Village depiction, don't be surprised when you realize that shadow is not another person in your tour group, but a ghost of a monk who once lived in or possibly practiced his religious profession on the historical church grounds," claimed Rebecca Muller from the website *Salem Witch City Ghosts.* "People have felt extreme cold breaths of air, and the feather-light touch of ghostly fingers on their arms and back. Others have heard a deep, male ghostly voice humming when there are no other men in the building at the time."

Yes, the building at 16 Lynde Street occupies a space that was formerly a place of worship. The structure's last tenants were Christian Scientists. The museum also boasts the original beam salvaged from the Salem's Witch

Gaol, a relic pulled from a lower dungeon hidden beneath 10 Federal Street. Some believe the activity associated with the Witch Dungeon Museum is triggered by the enchanted piece of wood.

"I've worked at the Witch Dungeon Museum for eight seasons and have certainly met some characters," said Meaghan Dutton-Blask, a fellow ghost tour guide who got her start in Salem. "One woman was a dungeon veteran and vehemently claims there's a ghost in the dungeon, a male spirit who wears red pants and aggressively tries to seduce her when she is alone in the dungeon," mused Dutton-Blask to *Ghosts of Salem*. "Many 'dungeonettes' have claimed that one portion of the museum—the section showing a repentant accuser later in life—has some sort of presence who tries to push the guide down the stairs."

Dutton-Blask said the haunted section of the dungeon museum is off limits to tourists, but "the guide may enter the exhibit to try to 'scare' the guests, and often has a hard time coming down from the steps feeling that a force is pushing her forward," she said. "I personally have never experienced this."

The tour guide said she's creeped out the most by the Witch Gaol beam. "The most compelling story for me is attached to the artifact in the museum," she said. "In the dungeon there is a beam that was a support beam in the original 'Witch Gaol.' The dungeon was one hundred yards from the location of the museum."

Dutton-Blask said several paranormal investigators have visited the museum and have taken photos of the macabre artifact. "Two photographers on separate occasions have picked up photos of a woman dressed in eighteenth-century clothing standing under the beam, always in the right-most position under the beam," she explained. "Of course, the witch hysteria took place in the seventeenth century, which is what makes this story more intriguing to me."

Why would investigators pick up a Revolutionary War–era entity? "I believe, if you look at old maps, there was an old fort at the 16 Lynde Street location," Dutton-Blask continued. "Perhaps the lady is a Revolutionary War–era resident of Salem who happens to appear in the location of the old fort but has attached herself to another psychically important piece of architecture from the century before?"

If the Witch Museum Dungeon is in fact haunted, it's definitely possible that spirit energy is attached to the Witch Gaol artifact. According to paranormal researchers who believe in the Stone Tape theory, inanimate objects like a wooden beam plucked from a dungeon can absorb some

form of energy from living beings that was "recorded" during an intense moment of their life.

"A residual haunting—trapped energy—is more likely stored by an item near the event," explained the authors of *Haunted Objects: Stories of Ghosts on Your Shelf*. "It becomes almost like a character...a crystal lamp or a setting of silverware becomes haunted and then replays the moment when the right environmental tumblers fall into place. The object can be moved to another location and when the situation is right, the recording replays, creating a haunting."

File under: dungeon's demons

THE WITCH HOUSE

It's the last structure standing in Salem with direct ties to the witch trials hysteria of 1692. Home of judge Jonathan Corwin, a magistrate with the Court of Oyer and Terminer, which sent nineteen to the gallows, the so-called Witch House dates back to 1675 and is an icon of America's tortured past.

Paranormal investigators consider the seventeenth-century structure hallowed ground. In fact, teams including Spirit Finders Paranormal Investigators from Rhode Island fought to set up ghost-hunting equipment in the old-school building. "We're hoping to see if Judge Jonathan Corwin still resides there," said investigator Christopher Andrews in a 2008 *Boston Globe* article. "We have heard rumors of people seeing an old man sitting in one of the rooms."

Access to the house was denied. Members from the Park and Recreation Commission thought it would be in poor taste to investigate the Corwin dwelling. "We have to have respect for the gravity of the injustice that occurred in 1692," responded board member Chris Burke. "This is sort of a touchy subject," said Elizabeth Peterson, director of the house. "We want people to be aware that we're not a Salem witch attraction."

In 2011, the governing board apparently changed their minds and allowed the crew from the Travel Channel's *Ghost Adventures* to set up an overnight lockdown. When Zak Bagans, Aaron Goodwin and Nick Groff walked into the Witch House, all hell broke loose.

"In broad daylight with [Witch House director] Elizabeth Peterson and talking to her, things got really weird," Groff told the *Boston Herald*. "Zak was filming and the batteries on his wireless mike kept dying. There was some

Magistrate Jonathan Corwin's home, known as the Witch House, is the last structure standing in Salem with direct ties to the witch trials hysteria of 1692. The Travel Channel's *Ghost Adventures* investigated the historic structure in 2011 and captured convincing evidence of the paranormal. *Courtesy of the Boston Public Library.*

sort of energy causing his batteries to die. We felt something weird, felt cold and then the batteries died."

Groff's team fought for years to gain access to the historic property. "We've already captured a voice and we just stepped into the house to start talking about history," Groff continued. "I think we're going to be in for a long night of finding paranormal activity."

The crew supposedly picked up a child humming and an EVP of Bridget Bishop, who named "Mary" as her accuser. She kept repeating the word "apple." In Christian Day's *The Witches' Book of the Dead*, he claimed to have summoned Bishop's spirit away from her usual post at the Lyceum. "I didn't want anyone living or dead to steal the spotlight from the Witch House," he wrote. "The team mentioned recording some strong activity on the second floor, but their machines really started to get going once we arrived. Real Witches are magnets for the dead," he

said, adding that he performed a necromantic blessing in the house, which included a blood offering.

Groff, in a later interview with *Ghosts of Salem*, said the lockdown was a historical goldmine. "The location, the Witch House, is just absolutely awesome. To be able to walk back in time, regardless of the paranormal activity that's actually occurring there, it's just cool to step foot on those wood floors and experience the environment of what it could have been like," he said. "You're almost stepping back in time. Whatever paranormal stuff that happens there is a plus to me. It's a cool place."

In hindsight, Peterson said she has mixed feelings about the investigation. "Personally, I was very uncomfortable doing it. I love this sort of thing, so it wasn't the subject matter," Peterson told me. "They were lovely kids, but I don't think they were a good match for the house. When they were off camera, they were very different. When their camera started running out of batteries, they did pick up a child humming. My first response was shock. My second, as a mother, is that it saddens me that there may be a child's spirit here that I wasn't sensitive to or was unaware of in the house."

Peterson believes the EVP captured on *Ghost Adventures* was questionable. However, she's not saying the Witch House is free of residual energy. "There were eleven deaths in this house up until 1719," she said. "Enormous amounts of human drama unfolded in these rooms. My son thinks he's seen things, and I think I've heard things."

As far as hauntings, visitors claim to hear phantom footsteps upstairs and eerie whispers throughout the structure. Employees reported seeing inexplicable shadows in the upper floors. Psychics believe there's an angry male energy lingering in the first floor and the residual haunting of two females, one believed to be a servant trying to hide an illegitimate pregnancy.

"There's nothing malevolent here," said one Witch House tour guide. "It's subtle things. Sometimes we'll think we hear footsteps above us in the attic when nobody is in the house. A tour guide and myself were setting up for a night event, the door was locked and we did hear a shuffle in the attic. A couple of people have maintained they heard their name called when nobody else was here."

Lara Jay, another tour guide with the Witch House, confirmed the reports of paranormal activity on the History Channel 2's *Haunted History* documentary. According to her televised interview, Jay was going over with two visitors a list of those executed during the witch trials. She witnessed a tin sconce literally fly off the wall. Jay also encountered what paranormal

experts call a "shadow person" in the Witch House's attic. "I saw a shadow pass on the other side of the door. I went in the room, and no one was there," Jay said. "I couldn't grasp that what I saw wasn't a living human being walking through the door...that it wasn't a human shadow."

File under: Corwin's return

SOURCES

The material in this book is drawn from published sources, including issues of the *Boston Globe, Boston Herald, Salem Evening News* and North Andover's *Eagle-Tribune,* and television programs like the Travel Channel's *Ghost Adventures,* the History Channel 2's *Haunted History* and Syfy's *Ghost Hunters.* Several books on Salem's paranormal history were used and cited throughout the text. Other New England–based websites and periodicals, like my site SalemUncommon.com, Salem Witch City Ghosts and *Zagat,* served as sources. I also conducted firsthand interviews, and some of the material is drawn from my own research. My Salem-based ghost tour, Salem Witch Haunts, was also a major source and generated original content. It should be noted that ghost stories are subjective, and I have made a concerted effort to stick to the historical facts, even if it resulted in debunking an alleged encounter with the paranormal.

Baltrusis, Sam. *Ghosts of Boston: Haunts of the Hub.* Charleston, SC: The History Press, 2012.

———. *Ghosts of Cambridge: Haunts of Harvard Square and Beyond.* Charleston, SC: The History Press, 2013.

Balzano, Christopher. *Haunted Objects: Stories of Ghost on Your Shelf.* Iola, WI: Krause Publications, 2012.

Boyer, Paul, and Stephen Nissenbaum. *Salem Possessed: The Social Origins of Witchcraft.* Cambridge, MA: Harvard University Press, 1974.

Cahill, Robert Ellis. *Haunted Happenings.* Salem, MA: Old Saltbox Publishing House, Inc., 1992.

———. *New England's Ghostly Haunts.* Peabody, MA: Chandler-Smith Publishing House, Inc., 1983.

———. *New England's Witches and Wizards.* Peabody, MA: Chandler-Smith Publishing House, Inc., 1983.

Calef, Robert. *Another Brand Pluckt Out of the Burning or More Wonders of the Invisible World.* London: Nath. Hillar at the Princess-Arms, 1697.

D'Agostino, Thomas. *A Guide to Haunted New England.* Charleston, SC: The History Press, 2009.

Day, Christian. *The Witches' Book of the Dead.* San Francisco, CA: Weiser Books, 2011.

Dowgin, Christopher Jon Luke. *Salem Secret Underground.* Salem, MA: Salem House Press, 2012.

Forest, Christopher. *North Shore Spirits of Massachusetts.* Atglen, PA: Schiffer Publishing, 2003.

Guiley, Rosemary Ellen. *Haunted Salem.* Mechanicsburg, PA: Stackpole Books, 2011.

Hauk, Dennis William. *Haunted Places: The National Directory.* New York: Penguin Group, 1996.

Hill, Frances. *Hunting for Witches.* Carlisle, MA: Commonwealth Editions, 2002.

Jasper, Mark. *Haunted Inns of New England.* Yarmouthport, MA: On Cape Publications, 2000.

Kampas, Barbara Pero. *The Great Fire of 1914*. Charleston, SC: The History Press, 2008.

Macken, Lynda Lee. *Haunted Salem & Beyond*. Forked River, NJ: Black Cat Press, 2001.

Nadler, Holly Mascott. *Ghosts of Boston Town: Three Centuries of True Hauntings*. Camden, ME: Down East Books, 2002.

Powers, Edwin. *Crime and Punishment in Early Massachusetts*. Boston: Beacon Press, 1966.

Revai, Cheri. *Haunted Massachusetts: Ghosts and Strange Phenomena of the Bay State*. Mechanicsburg, PA: Stackpole Books, 2005.

Rule, Leslie. *When the Ghost Screams: True Stories of Victims Who Haunt*. Kansas City, MO: Andrews McMeel Publishing, 2006.

Saville, Susanne. *Hidden History of Salem*. Charleston, SC: The History Press, 2010.

Wilhelm, Robert. *Murder & Mayhem in Essex County*. Charleston, SC: The History Press, 2011.

Zwicker, Roxie J. *Haunted Pubs of New England: Raising Spirits of the Past*. Charleston, SC: The History Press, 2007.

ABOUT THE AUTHOR

Author Sam Baltrusis launched a spirited holiday tour called Boston Haunts in addition to his historical-based ghost walks in Cambridge and Salem. Next stop? Provincetown. *Photo by Nick Cox.*

S am Baltrusis, author of *Ghosts of Boston: Haunts of the Hub* and *Ghosts of Cambridge: Haunts of Harvard Square and Beyond*, freelances for various publications and teaches journalism classes at Cambridge Community TV (CCTV) and Malden Access TV (MATV). He has been featured as Boston's paranormal expert on the Biography Channel's *Haunted Encounters* and *Paranormal State*'s Ryan Buell's *Paranormal Insider Radio*. As a side gig, Baltrusis moonlights as a guide and launched the successful ghost tour, Cambridge Haunts, and produced a new tour in Salem highlighting the city's historical haunts. He's also a sought-after lecturer who speaks at dozens of paranormal-related events scattered throughout New England. In the past, he's worked for VH1, MTV.com, *Newsweek* and ABC Radio and as a regional stringer for the *New York Times*. Visit GhostsofSalem.com for more information.